Japanese Paper Flowers

Elegant Kirigami Blossoms, Bouquets, Wreaths and More

Hiromi Yamazaki

TUTTLE Publishing

Tokyo | Rutland, Vermont | Singapore

Contents

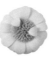
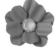
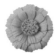

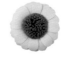
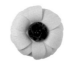

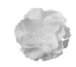

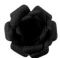
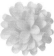
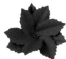
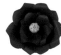
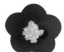
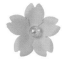

The Beauty and Simplicity of Paper Flowers

All of these flowers are made only with paper!
Just cut flower shapes from paper, fold them, and shape them.
Putting all the parts together creates a thing of beauty.
You don't have to limit yourself to the flowers in the templates.
Try using different kinds of paper in different colors, and make arrangements with flowers of your choosing to come up with your own original creations.

I hope you enjoy the elegant world of paper flowers!

Hiromi Yamazaki

> With just paper and scissors, it's remarkably simple to create 3D blooms. That's what makes paper flowers so fantastic.

① Use the templates to cut the flower shapes

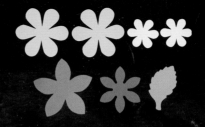

② Curl the petals

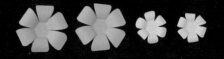

③ Arrange the parts and secure as directed

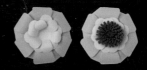

④ Complete!

Materials Notation Key

On the how-to pages, notations for specific materials needed are as shown below. Refer to the instructions for paper color.

Paper Flower Instructions (pages 48–75)

Petals, stamens, sepals, leaves, and stems to be made from paper

Dandelion [see photo page 7]

Flower size: ~ 1⅛-in (3-cm) diameter

MATERIALS (ONE FLOWER)

Petals ●
 page 92, template 92-5—2 pieces
 page 92, template 92-6—2 pieces

Stamen ●
 ⅜ x 6 in (1 x 15 cm)—1 piece

Sepal ●
 page 95, Sepal D template—1 piece

Leaf ●
 page 95, Leaf A template—1 piece (cut in half)

Stem: paper-covered wire—2 pieces, floral tape

Paper color suggestions

Template page number and quantity needed

Arrangements and Decorations (pages 76–90)

Wreath 1

The Rose-Bearer [see photo page 16]

FLOWERS USED ※ Damask Roses without the sepal and stem, and Lily of the Valley without the stem

Damask Rose
> page 65

Rosebud
> page 66

Lily of the Valley
> page 49

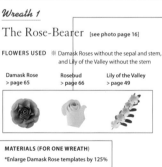

MATERIALS (FOR ONE WREATH)

*Enlarge Damask Rose templates by 125%

Damask Rose ○—9 flowers; ○ & ●—4 flowers;
 ● ●—2 flowers
Rosebud ●—3 flowers
Lily of the Valley ● & ● & ●—15 clusters
Leaves: page 95, Leaf A template ●—12 leaves;
 ●—13 leaves

Wreath base (8-in / 20-cm diameter)—1 piece
Green tulle or craft netting (2⅜ x 2⅜ in / 6 x 6 cm)
 —as needed
Hemp string—as needed

Flowers used in the items

Paper color suggestions

Different paper colors used in a single flower are separated with "&" in the notation

5

The Paper Flowers

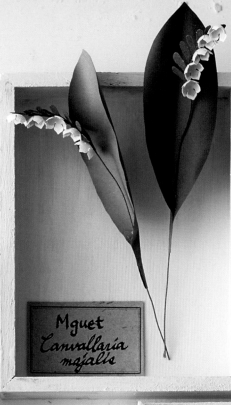

Lily of the Valley

page 49

Mguet
Canvallaria
majalis

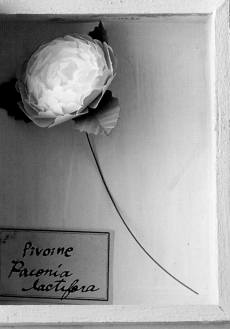

Peony

page 50

Pivoine
Paconia
lactifora

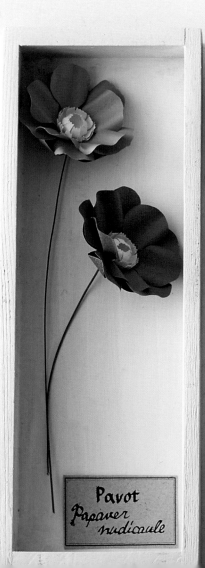

Poppy

page 48

Pavot
Papaver
nudicaule

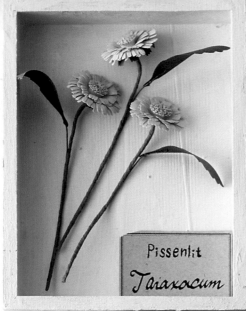

Dandelion

page 51

Pissenlit

Taraxacum

Anemone

page 52

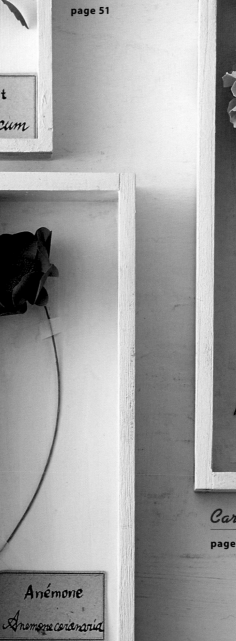

Anémone

Anemone coronaria

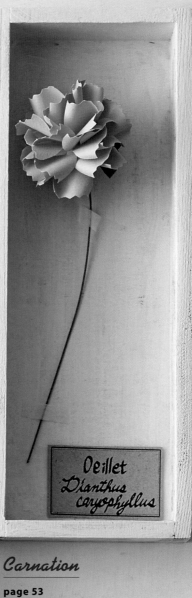

Oeillet

Dianthus caryophyllus

Carnation

page 53

7

Marguerite
Argyranthemum
Truck

Tulipe
Tulipe

Gerbera

English Daisy

page 54

Shasta Daisy

page 55

Tulip

page 55

Gerbera Daisy

page 57

Madonna Lily

page 58

lys
Lilium

Easter Lily

page 59

Hortensia
Hydrangea
macrophylla

Hydrangea

page 59

9

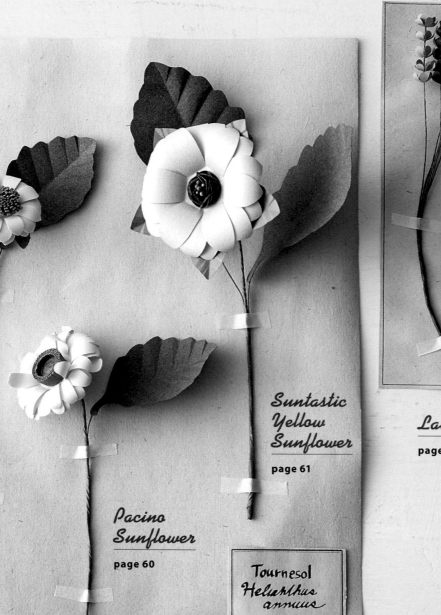

Sunny Smile Sunflower
page 61

Suntastic Yellow Sunflower
page 61

Pacino Sunflower
page 60

Tournesol
Helianthus
annuus

Lavande
Lavandula

Lavender
page 61

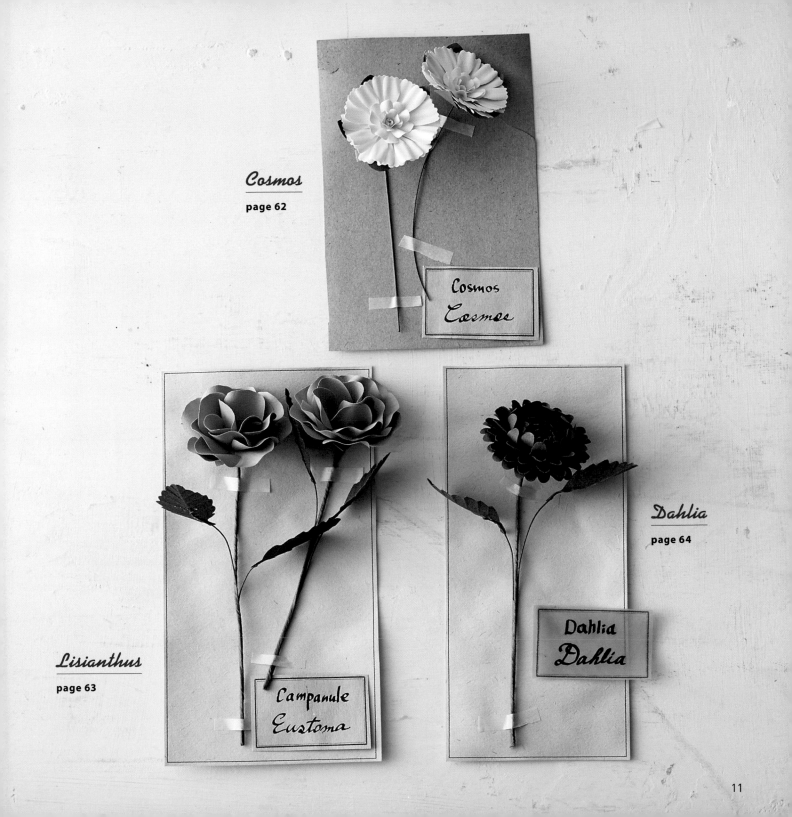

Cosmos

page 62

Cosmos
Cosmos

Lisianthus

page 63

Campanule
Eustoma

Dahlia

page 64

Dahlia
Dahlia

11

Damask Rose
page 65

Rosebud
page 66

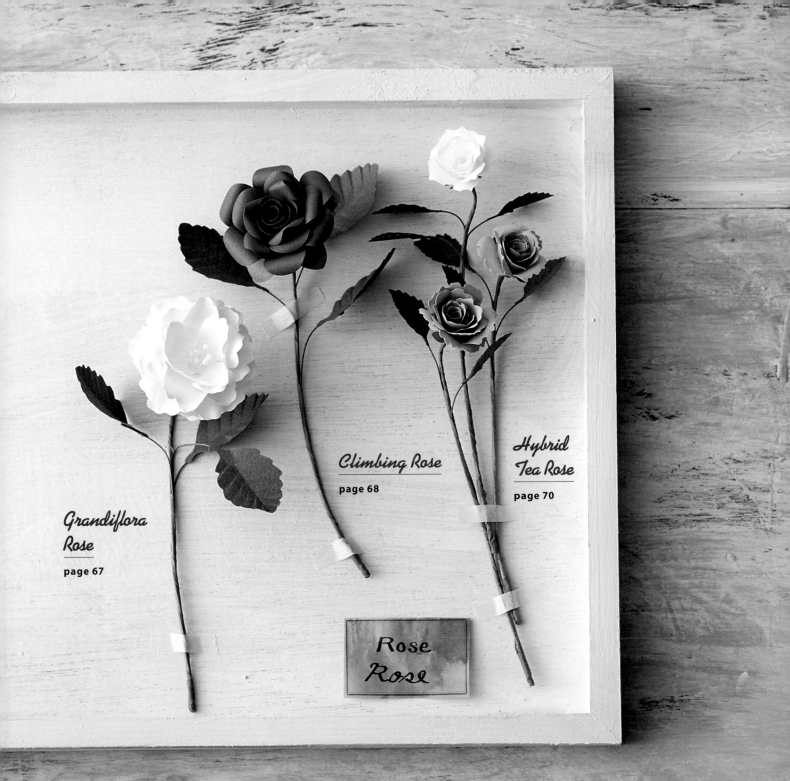

Grandiflora
Rose

page 67

Climbing Rose

page 68

Hybrid
Tea Rose

page 70

Rose
Rose

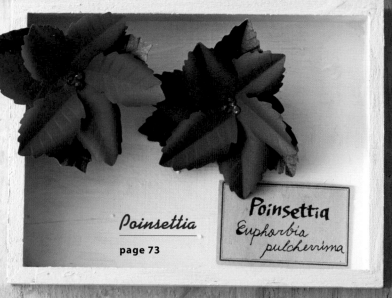

Pom-Pom Chrysanthemum

page 71

Semi-Double Chrysanthemum

page 72

Chrysantéme

Chrysanthemum

Poinsettia

page 73

Poinsettia

Euphorbia pulcherrima

Fleur de Prunier
Prunus mume

Camellia

page 73

Cherry Blossom

page 75

Plum Blossom

page 74

Camelia
Camelia japoica

Fleur du Ceriser
Prunus

15

Making Arrangements and Accessories

Wreath 1

The Rose-Bearer

White roses are the theme of this elegant arrangement.
Rows of white lilies accentuate the roses, giving the wreath a unique look.
It is inspired by the traditional silver rose of engagement from the opera *Der Rosenkavalier* by Richard Strauss.

Instructions on page 77

Wreath 2

Flowers in Wonderland

This wreath is filled with a gorgeous variety of colorful flowers.
It's not just meant to be viewed from the front, either—the sides are also bursting with blooms, making it a real showstopper.
The abundance of vivid hues and shapes in this arrangement give it a fairy-tale feeling.

Flower Lamp

And the Stars Were Shining

A lamp strung with white roses and lisianthus.
Suitable for decorating tables or shelves, or for draping on walls. This illuminates a room with gentle light.

Instructions on page 80

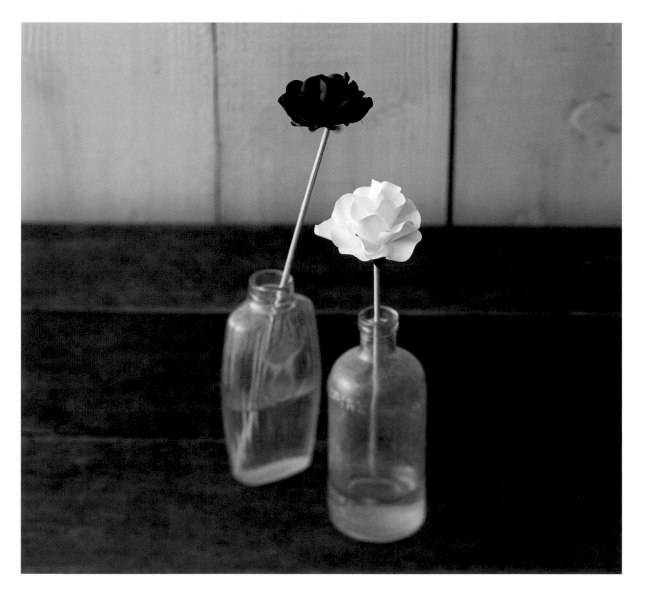

Aroma Diffuser

The Dowager

Like an aristocratic lady in a white dress coat stepping out at a high-society dance soiree.
A pair of aromatic lisianthus, very easy to make.

Instructions on page 80

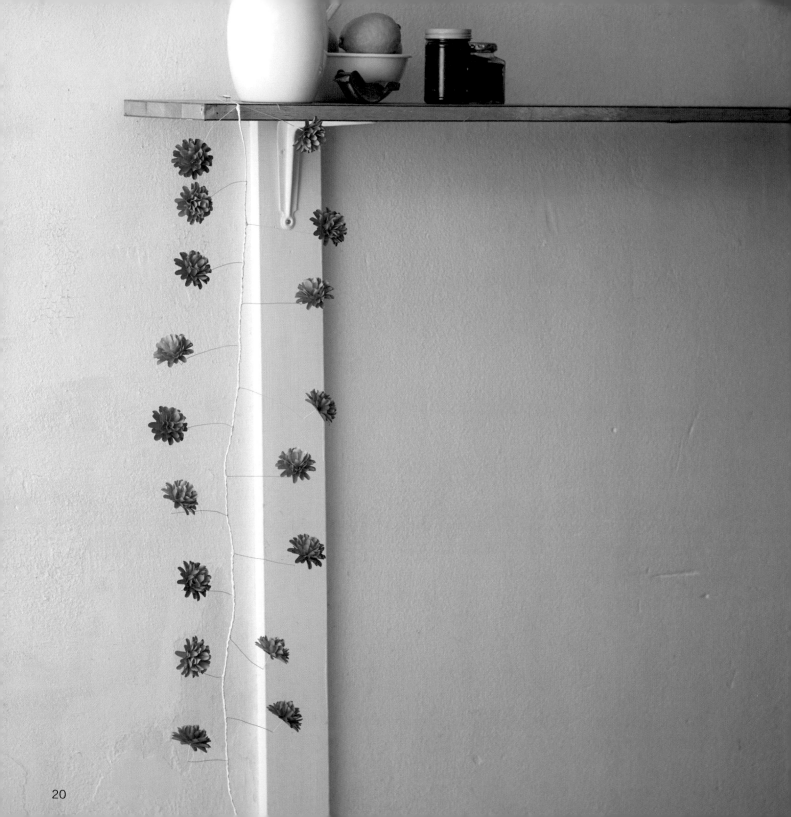

Hanging Garland

Flower to Flower

A nicely balanced garland of vividly colored chrysanthemums strung together with wires.
It has the sprightly step of a well-rehearsed waltz.

Instructions on page 81

Almost Seventeen

A mini-bouquet of peonies and roses.
The soft colors of this arrangement
evoke a maiden who hasn't yet learned
how to love.
More casual than fresh flowers, this
bouquet would be a lovely small
birthday present or gift.

Instructions on page 82

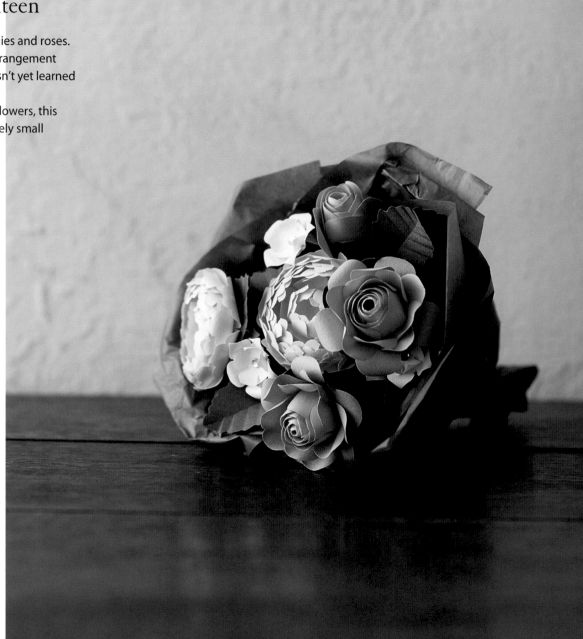

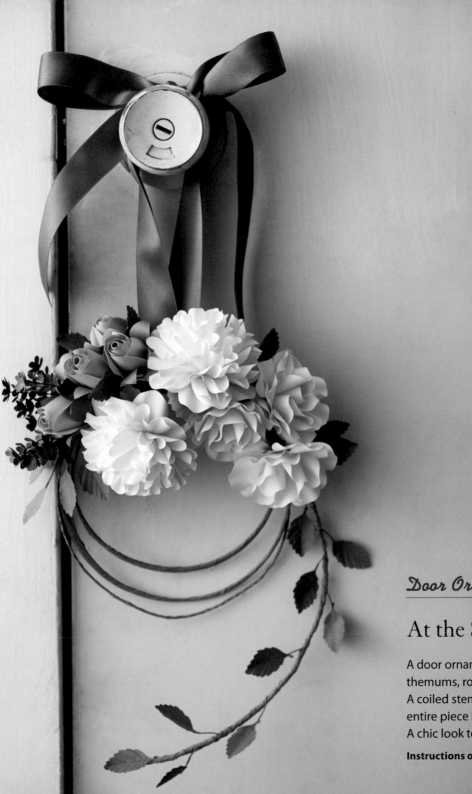

Door Ornament

At the Summer Villa

A door ornament of semi-double chrysan-
themums, rosebuds, and lavender.
A coiled stem of ivy serves as the base; the
entire piece hangs from a pretty ribbon.
A chic look to welcome guests to the house.

Instructions on page 83

Ophelia's Song

These are the flowers picked by a heartbroken Ophelia. Using a pen for the stems makes a truly expressive bouquet.
Wrapped in green floral tape, these will add a lively touch to your desk.

Instructions on page 84

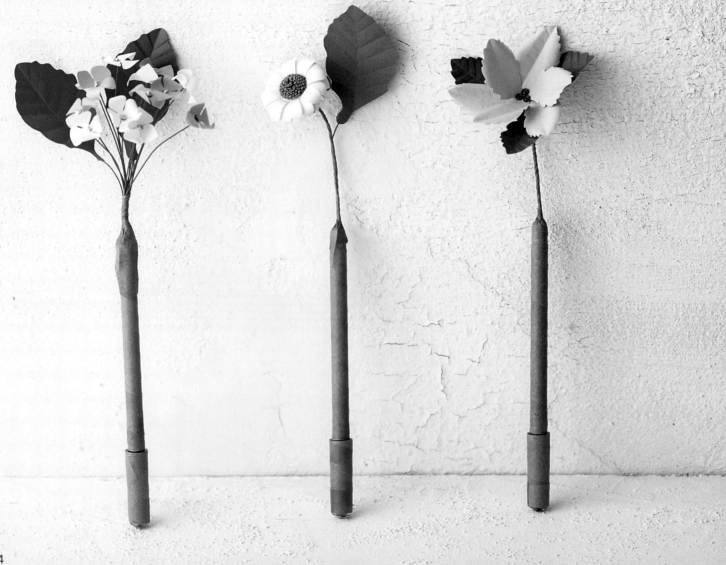

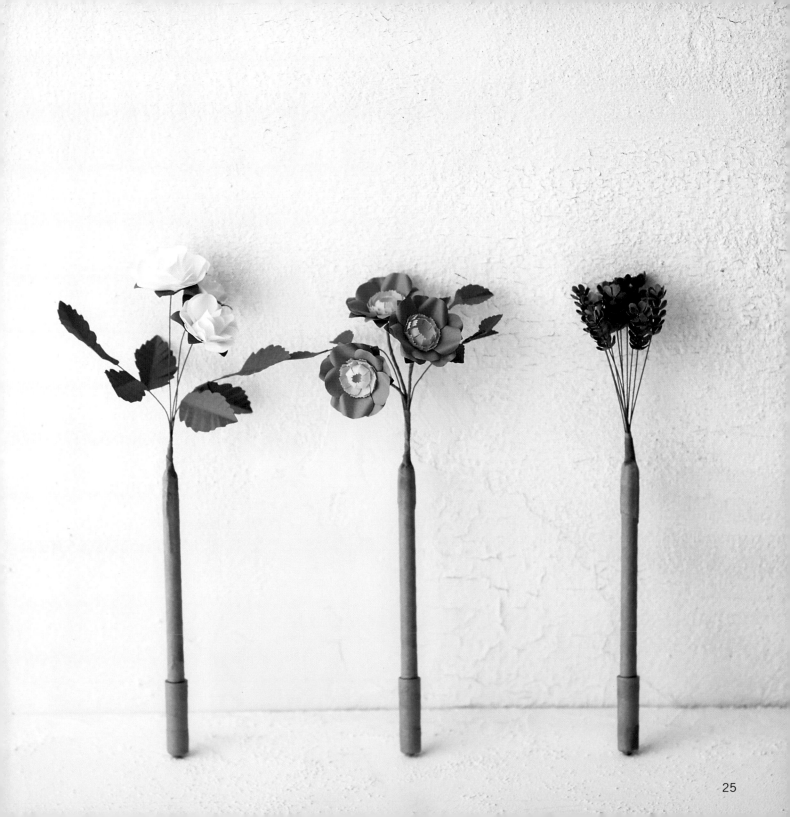

Prayer

Symbols of the Virgin Mary, blue roses and Easter lilies—"God's Blessing" in flower language—are put together like a Japanese *kusudama* ornament. A chain of pearly beads suspended from the flowers adds to the elegance. Extra flowers can be arranged in a glass container to create a striking interior piece.

Instructions on page 85

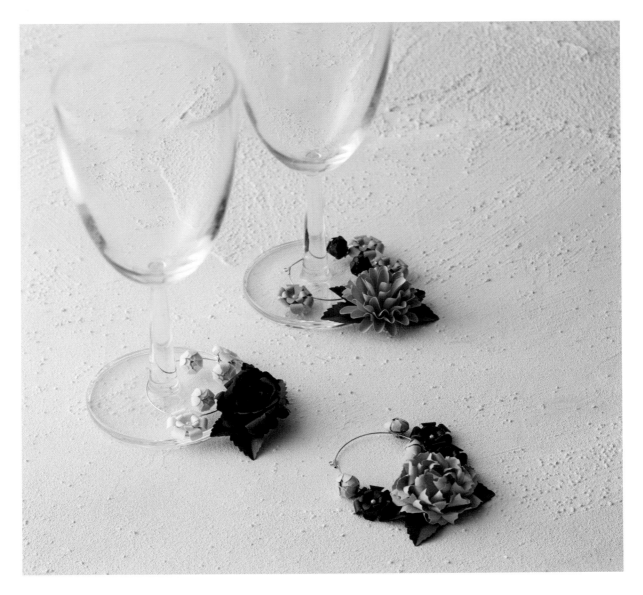

Wine-Glass Corsages

The First Waltz

Identify your drink with your favorite flower. The flowers are attached to a wire hoop.
As you pick up the glass, the flowers swing around like the hem of a prom dress.

Instructions on page 86

Corsage

What's Your Wish?

This corsage of anemones is like a mini-bouquet. The color gradations in the petals are done with an ink pad. The refined shapes and hues have a sophisticated feel.

Instructions on page 86

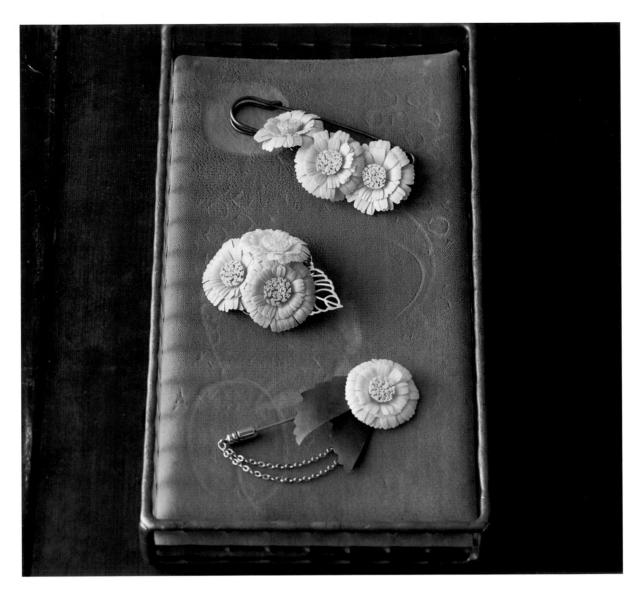

Brooches

Is This Love?

Three different brooches using dandelions. Changing the colors, the number of flowers, or the base of these brooches results in different designs. A sweet accent for clothes and accessories.

Instructions on page 87

The Secret Letter

Romances so often feature stories of forbidden, secret love. Such tales call to mind the quiet
yet heartfelt colors of the chrysanthemums and roses that surround this frame.

Instructions on page 88

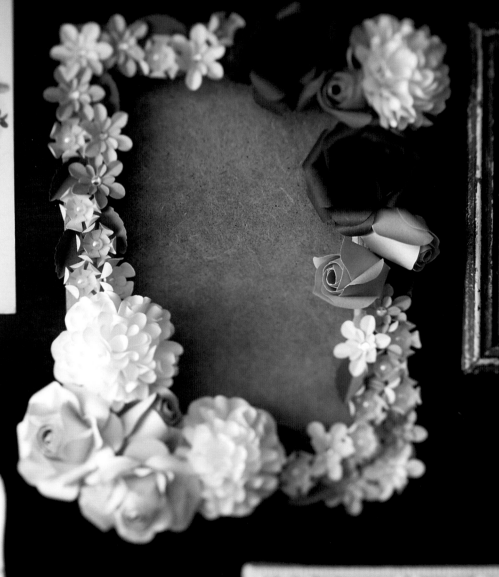

Bookmarks

A Date at the Library

Daisies, poppies, and dandelions adorn these lovely bookmarks. The stems are made out of ribbons with attached accent leaves. The flowers and leaves peek out from between the pages when in use.

Instructions on page 88

Tassels

The Nightingale

These tassels combine large and small flowers like gerbera daisies and lilies of the valley.
Waiting patiently by the window for Romeo to show up, they're a great accessory for curtains or drapes.

Instructions on page 89

Magnets

Once Upon a Sunny Day

Cherry blossoms, plum blossoms, and camellias are arranged like gorgeous butterflies.
A simple yet striking arrangement to grace a magnet.

Instructions on page 89

Coronet

Daydreaming

Envision yourself wandering through a field of daisies, plucking a few to make a delicate flower crown.

Instructions on page 90

Bracelet

He Loves Me, He Loves Me Not

A floral bracelet in soft colors to match your flower coronet. The blue ribbon gives it a pure look.

Instructions on page 90

The Paper Flower Basics

Materials

Paper is the heart of these flowers! Let's take a look at the materials below.

PAPER
Petals, stamens, leaves and such are all mostly made from paper. The flowers shown in this book, were made with 100 gsm weight TANT origami paper. To minimize the likelihood of tearing the paper as you work, I recommend using paper between 100 and 160 gsm. (Note: (TANT origami paper is available on Amazon.com)

PAPER-COVERED WIRE
Used for flower stems.
I recommend #22 or #24 thickness.

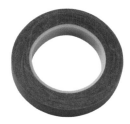

BEADS, RHINESTONES, PEARLS, ETC.
Used for flower stamens. The sticker type makes glue unnecessary. Liquid Pearls are a type of acrylic paint that resembles pearl beads when it is dry.

FLORAL TAPE
To assemble flower stems. This book mainly uses green or brown tape.

Tools

The work involves cutting out, bending and creasing, and attaching parts together. These are basic household tools that should be easy to find.

TWEEZERS
Used to attach small things. Also used to make creases in leaves.

TRACING STYLUS
Used to curl paper.

GLUE
Wood or paper glue will work; the adhesive should be transparent when it dries. A fine-tipped applicator makes things easy.

SCISSORS
Used to cut out petals and leaves. Dedicated craft scissors are ideal.

Other Useful Tools

RULER
Used to fold straight lines or cut straight lines.

EMBOSSING PEN AND MAT
Used for making petals (page 39). If you don't have a mat, you can use a thick piece of felt.

CRAFT KNIFE AND PAPER SLICING MAT
Useful for cutting straight lines. You can see these being used on page 43, in the section on making flower stamens.

CRAFT SPATULA
Particularly useful for making precise edges when folding.

INK PADS
Ink pads let you easily add color to petals and leaves, giving your paper flowers more depth. (For more detail, see page 47.)

PAPER PUNCH
A punch makes it easy to cut out detailed shapes. The flower-shaped ones are especially handy!

DECOUPAGE GLUE
Use this to strengthen surfaces or make them waterproof.

Making a Simple Flower

In order to make a flower, you first need to create the individual parts: petals, stems, sepals, and stamens. As an exercise to learn the basic steps of shaping the paper, begin by making the flower shown here.

Step 1: Preparing the Parts

Prepare the parts by using the templates provided on pages 91–95.

1 Create templates

Make templates by tracing the shapes in the back of the book or copying them on a copier. Cut out the shapes.

2 Outline the flower shape

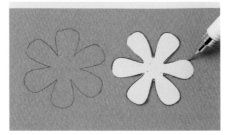

Use a pencil to trace the flower shapes on the back of the paper you're using for the petals. This will ensure that the pencil lines don't show on the finished flower.

3 Cut out the flower shape

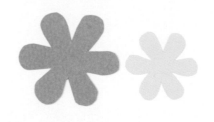

Cut the petals out along the lines you drew with the pencil in step 2.

| TIPS FOR MAKING PAPER FLOWERS |

Cutting Challenging Pieces

You can use a craft knife or paper punch to make parts that cannot be cut comfortably with scissors.

CUTTING OUT SMALL PARTS

A paper punch is great for making the detailed parts of the stamens. All you need to do is depress the punch, so you can quickly produce many little parts.

CUTTING OUT LONG PIECES

A craft knife and cutting mat work well for long pieces. Run the blade along the edge of a ruler to cut straight lines.

Lifting the Flower Petals

Before curling the ends of the petals, you can add dimension by lifting the petals from the center. You can use your fingers to do this to larger cutouts; for smaller cutouts, you can use an embossing or burnishing tool.

LIFTING PETALS BY HAND

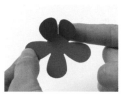

1 Use the tip of your finger to fold the petals inward. You don't have to crease the paper, just gently fold the paper toward you.

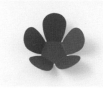

2 Repeat with the remaining petals.

USING A TOOL TO LIFT THE PETALS

1 On a embossing mat or thick felt pad, press the parts gently with an embossing pen.

2 Repeat to lift each petal.

Step 2: Curling the Petals

To give the petals a three-dimensional quality, curl them with a tracing stylus. The technique for curling the tips of the petals outward is shown here. For other ways to curl the petals, refer to pages 40–41.

1 Place the stylus

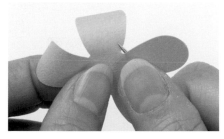

Place the stylus behind one of the petals.

2 Curl

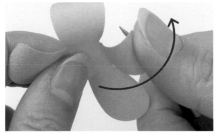

Sandwich the petal between the stylus and your thumb. Slide the stylus toward the tip of the petal. When you get close to the edge, gently roll your thumb partway around the stylus to curl the paper outward.

3 Repeat

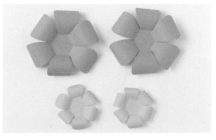

Repeat steps 1–2 for all petals.

Other Ways to Curl Petals

The flowers in this book have petals that curl in different directions.
Use your fingers or the tracing stylus and follow the same method as for curling the tips outward.

CURLING THE SIDES OF THE PETALS OUTWARD

1 Place the stylus

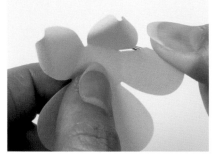

Place the stylus along the outer side, and slide it out to the side edge as shown in the picture.

2 Curl

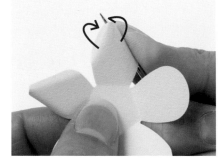

After sliding the stylus out against your thumb, you can make the shape symmetrical by using your fingers like so.

3 Repeat

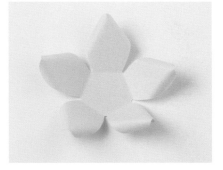

Repeat steps 1–2 for every petal.

CURLING THE SIDES OF THE PETALS INWARD

1 Place the stylus

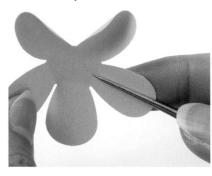

Place the stylus in the inner side and slide it out to the side edge as shown in the picture.

2 Curl

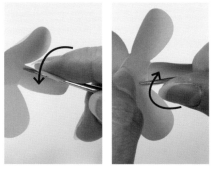

Use your index finger to support the inward curling on one end, and your thumb on the other end.

3 Repeat

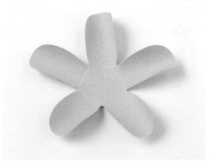

Repeat steps 1–2 for every petal.

CURLING THE TIPS OF THE PETALS INWARD

1 Place the stylus

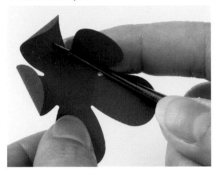

Place the stylus in the inner side at the center crosswise, as shown in the picture.

2 Curl

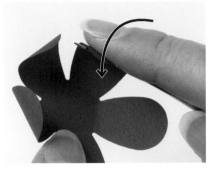

Place your index finger on the outer side and press it against the stylus; start curling the petal inward.

3 Repeat

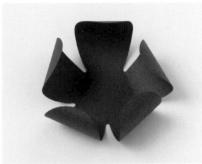

Repeat steps 1–2 for every petal.

MAKING RIDGED PETALS

1 Place the stylus

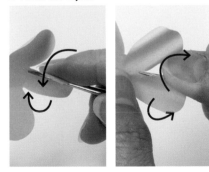

Place the stylus lengthwise on the inside of the petal and curl inward with your index finger, then place the stylus lengthwise on the outside and curl outward with your thumb.

2 Repeat

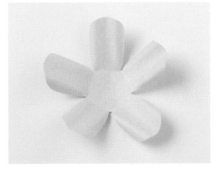

Repeat step 1 for every petal.

CURLING VARIATIONS

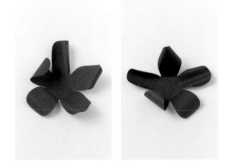

You can practice the different methods shown here by curling the petals of a flower cutout in various directions.

Step 3: Stacking the Parts

After curling the petals, you can combine your cutouts to make a flower. Be sure to follow the tips given below for the best results.

1 Stacking two cutouts

TIP

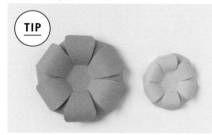

You can stack two cutouts of the same size.

2 Stacking two kinds together

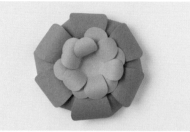

After stacking the same-sized cutouts as in step 1, you can combine the two stacks.

TIP To affix a stack, just put a dot of glue at the center of the cutout. Be careful to not use too much.

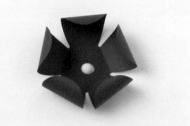

| TIPS FOR MAKING PAPER FLOWERS |

Balancing the Stacks

The number of petals will vary depending on the flowers you make. Here are techniques for balancing stacks.

STACKING TWO TO THREE CUTOUTS

1 Stack layers by size

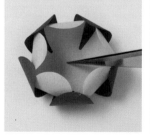

Stack the cutouts from large to small. To secure, add glue between layers and gently press the center of the stack.

2 Alternate petal alignment

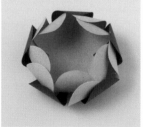

When stacking three cutouts, try alternating where the petals align.

STACKING MORE THAN 4 CUTOUTS

1 Stack two at a time

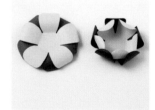

Glue same-sized cutouts together.

2 Combine the two

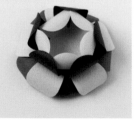

Place the smaller stack on the larger one, alternating the petal position slightly.

Step 4: Making the Stamen

Next we'll be making the stamen. Here we'll make the double-fringed stamen. For other types of stamens, please refer to page 44.

1 Cut

Height of the stamen

Cut out a strip of paper. Its width should be twice the desired stamen length. For a stamen that is 1¾ inches (4.5 cm) or more in diameter, the paper should be about 6 to 8 inches (15 to 20 cm). For a diameter of less than 1¾ inches (4.5 cm), make it 4 inches (10 cm) long.

2 Fold

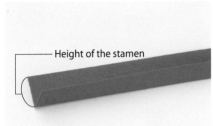

Height of the stamen

Fold the long paper cutout in half lengthwise.

3 Snip

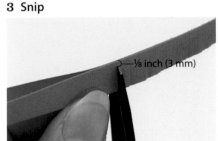

⅛ inch (3 mm)

Use the tips of the scissors to start cutting the fringe on the folded side. End each cut about ⅛ inch (3 mm) from the edge of the paper.

4 Roll

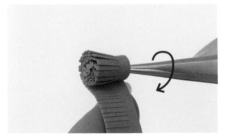

After cutting the fringe, grasp one end with tweezers and roll the paper around tightly.

5 Attach

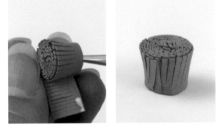

Put a dab of glue on the end of the paper and seal the roll closed. Secure with a rubber band, if needed.

6 Open

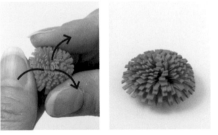

When the glue is dry, open the fringe outward. How much you open the fringe depends on which flower you are making.

7 Attach to flower petals

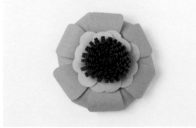

Now you can attach the stamen to the stack of petals.

TIP For a very narrow fold, it is helpful to crease before folding. ① Lay the paper on the cutting mat, place the ruler where you want the fold, and slide the embossing pen down along the ruler to make a crease. ② Fold the paper in by hand. ③ Use the craft spatula to press the fold flat.

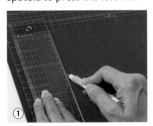
①

②

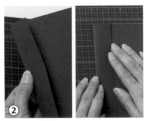

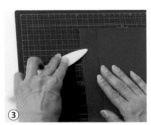
③

Other Ways to Make Stamens

In addition to the double-fringed one shown on page 43, there are simpler stamens.

SIMPLE STAMEN

1 Cut

— Height of the stamen

Cut a long, narrow strip of paper. Its width will be the actual height of the stamen.

2 Roll

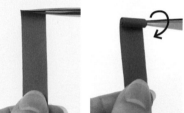

Grasp one end of the paper with tweezers and roll the paper around the tips.

3 Seal

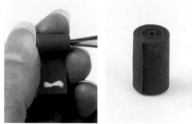

Apply a dab of glue to end and seal the roll closed.

SINGLE-FRINGED STAMEN

1 Cut and snip

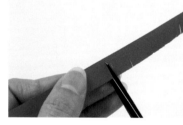

Cut a long, narrow strip of paper. Snip the fringe with the tips of the scissors as for the double-fringed stamen on page 43. Keep about a ⅛-inch (3-mm) base.

2 Roll

Grasp one end of the paper with tweezers and roll the paper around the tips.

3 Seal and open

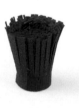

Apply glue to the end of the paper and seal the roll closed. When the glue is dry, open the fringe outward.

USING A CUTOUT TEMPLATE

The methods for petals shown on pages 38–42 can also be used to make a stamen. You can place a cotton bud or a bead at the center.

Stamen for Poppy (page 48)

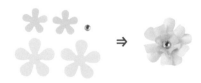

Stamen for Cosmos (page 62)

Flower petals and leaves are rolled in the same way. To make leaves look more realistic, you can use tweezers to make creases for the veins of the leaves.

1 Prepare the parts of the leaf

Cut out a leaf from a template. We'll use paper-covered wire for the stem.

2 Fold the center

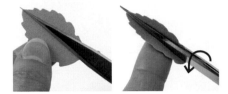

Grasp the center of the leaf cutout with the tweezers. Fold the leaf against the sides of the tweezers to make a crease.

3 Make diagonal creases

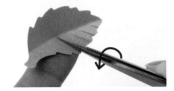

To create diagonal creases, grasp the part you want to make a crease in with the tweezers. Wiggle the tweezers from side to side a little until a line is visible.

4 Repeat

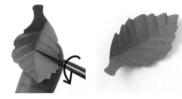

After you finish one side of the leaf, do the same to the other side.

5 Apply glue

Turn the leaf over and apply a thin bead of glue down the center.

6 Attach the stem

Attach the stem to the glue. Roll the stem to cover it with glue, adding a little more if needed, and let dry.

| TIPS FOR MAKING PAPER FLOWERS |

Making Creases in Flower Petals

To give some flowers the right character, you can add creases to the petals.

1 Secure

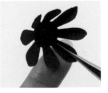

Grasp the petal vertically down the center with the tweezers.

2 Fold toward the center

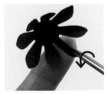

Make a crease on either side of the tweezers (same method as for making creases in a leaf above).

3 Repeat

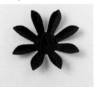

Repeat steps 1–2 to make a crease in each petal.

Now we'll add the sepal to the flower we made on pages 38–43.
First, the sepal is attached to the stem. Then the flower is glued on.

1 Prepare the parts

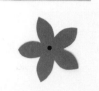

Cut out the sepal according to the given template. Use a pin or craft stylus to poke a hole in the center.

2 Make a loop in the stem

Use pliers to coil the end of the stem into a loop.

3 Bend the end of the stem

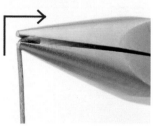

Bend the loop so that it is at a right angle to the rest of the stem.

4 Attach the stem to the sepal

Push the end of the stem without the loop through the hole in the sepal.

5 Glue the stem in place

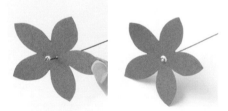

Put a drop of glue on the loop end of the stem. Pull the stem all the way through until the loop is against the sepal.

6 Glue the flower to the sepal

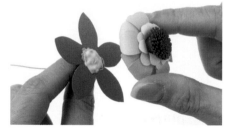

Apply glue to the center of the sepal and attach the flower.

7 Allow to dry

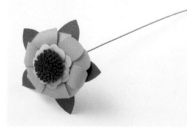

Let the glue dry completely.

8 Finish the sepal ends

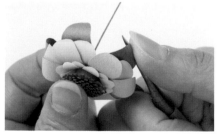

Once the glue is completely dry, you can curl the ends of the sepal as you like.

Here we will use floral tape to secure the leaf to the main stem. It's best to use a floral tape color that matches to stem color.

1 Wrap the stem and attach the leaf

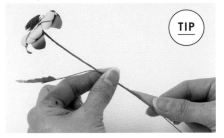

TIP

Start from the bottom of the sepal and wrap the stem in tape. Place the leaf stem about halfway down the main stem and wrap them together with the floral tape.

2 Complete the wrapping

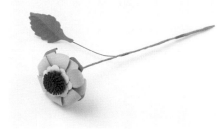

Finish wrapping the stem.

TIP Rotate the stem while you hold the floral tape, rather than moving the tape around the stem. Decide in advance whether this flower will be part of a bouquet, and wrap the stem accordingly. When wrapping a bouquet, it is helpful to use a rubber band to hold the flowers together.

| TIPS FOR MAKING PAPER FLOWERS |

Tinting and Reinforcing

Here are some techniques to add final touches to your flower.

TINTING

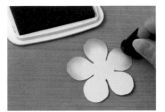

1 Add color to petals or leaves
(Note: This should be done before curling, creasing, or decoupaging your cutouts.) Press a small sponge onto a stamp pad. Gently dab the ink onto the paper to create gradations of color.

2 Shape the petals
Tint as desired, then allow to dry. Then you can start curling or creasing the petals or leaf cutouts.

REINFORCING

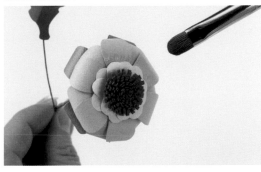

Depending on the materials used, your paper flower may tear or fall apart easily. Brush a thin layer of decoupage glue (see page 37) onto the flower. When the glue is dry, the flower will not tear as easily.

The Paper Flowers

Poppy [see photo page 6]

Flower size: ~ 2⅜-in (6-cm) diameter

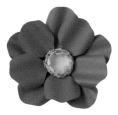

MATERIALS (FOR ONE FLOWER)

Petals ●
 page 92, template 92-1—1 piece
 page 92, template 9-2—1 piece

Stamen ○
 page 95, Stamen A template—4 pieces

Sepal ●
 page 94, Sepal A template—1 piece

Stem: paper-covered wire—1 piece

1 Prepare the pieces

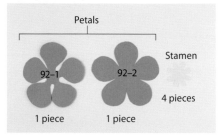

Cut out the parts according to the templates provided.

2 Curl the petals; stack and attach

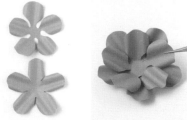

For both of the petal parts, curl both sides in lengthwise (page 41), then curl the tips outward. Place 92-1 on top of 92-2 and glue them together.

3 Cut and glue the stamen together

Take one stamen cutout and fold the fringes in so that they stand up (page 39). Curl the ends inward (page 41). Repeat with all four cutouts. Stack and glue the pieces together (page 42), alternating the edges as shown.

4 Glue the stamen to the flower

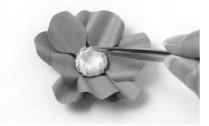

Put a dab of glue at the center of the stacked petals and secure the stamen.

5 Prepare the stem and sepal

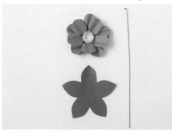

Prepare the stem and sepal parts. Loop and bend the stem as shown on page 46.

6

Put the stem and sepal together. Glue the flower to the sepal. Your Poppy is complete!

TIP After cutting out the stamen parts, use your tweezers to gently curl the fringes.

Lily of the Valley

[see photo page 6]

Flower size: ~ ⅜-in (1-cm) diameter

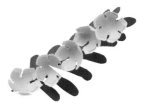

MATERIALS (FOR ONE CLUSTER)

Petals ○
 page 92, template 92-3—5 pieces
 ●
 page 92, template 92-4—5 pieces

Sepal ●
 page 95, Sepal B template—1 piece

Leaf ●
 page 95, Leaf B template—1 piece

Stem: paper-covered wire—1 piece

1 Prepare the pieces

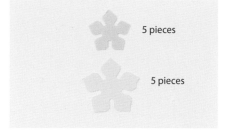

5 pieces

5 pieces

Cut out the parts according to the templates provided.

2 Stack and attach

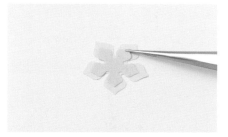

For both of the petal parts, curl both sides in lengthwise (page 41), then curl the tips outward. Place 92-1 on top of 92-2 and glue them together.

3 Shape the flowers

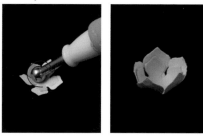

Use the embossing pen to curl the petals upward (page 39).

4 Add the sepal

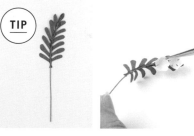

TIP

Apply a line of glue to the back of the sepal and place the stem on it. Once the glue has dried, start attaching the flower parts in a line along the front of the sepal.

5 Allow the glue to dry

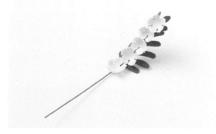

This is how the dried assembly will appear.

6 Complete the flower

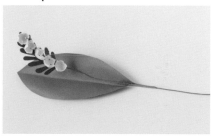

Apply glue to the base of the leaf. Wrap the base of the leaf partially around the stem to secure. Allow the glue on the leaf to dry. Your Lily of the Valley is complete!

Peony [see photo page 6]

Flower size: ~ 2-in (5-cm) diameter

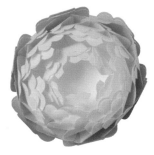

MATERIALS (FOR ONE FLOWER)

Petals ○
 page 93, template 93-2—2 pieces
 ○
 page 93, template 93-2—2 pieces
 ○
 page 93, template 93-1—2 pieces
 page 93, template 93-2—2 pieces
Sepal ●
 page 95, Sepal C template—1 piece
Stem: paper-covered wire—1 piece

1 Prepare the pieces

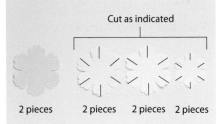

Cut as indicated

2 pieces 2 pieces 2 pieces 2 pieces

Cut out the petals according to the templates. Keep the two pink cutouts intact; use scissors to make cuts in the petals of the remaining six cutouts (as shown in the picture).

2 Curl the petals

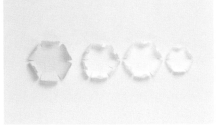

Curl all the petals inward (page 41). The petals with an extra cut should have each part curled individually.

3 Organize cutouts

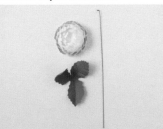

After curling all of the petals, work with same-colored pairs of cutouts.

4 Stack cutouts

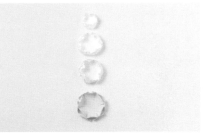

Stack and glue cutouts of the same size and color together, alternating the petals as on page 42.

5 Assemble the flower

Stack and glue the petals in the following order from the bottom: pink, gray, white. The white petals will be the center of the flower.

6 Add the sepal and stem

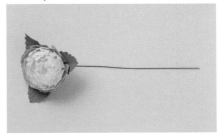

Prepare the sepal cutout. Make creases as shown for a leaf on page 45. Prepare the stem and attach the sepal (page 46).

7 Complete the flower

Glue the flower to the sepal. Your Peony is complete!

Dandelion [see photo page 7]

Flower size: ~ 1⅛-in (3-cm) diameter

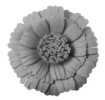

MATERIALS (FOR ONE FLOWER)

Petals ⚪
 page 92, template 92-5—2 pieces
 page 92, template 92-6—2 pieces

Stamen ⚪
 ⅜ x 6 in (1 x 15 cm)—1 piece

Sepal ⚫
 page 95, Sepal D template—1 piece

Leaf ⚫
 page 95, Leaf A template—1 piece (cut in half)

Stem: paper-covered wire—2 pieces, floral tape

1 Prepare the pieces

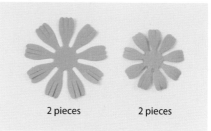

2 pieces 2 pieces

Cut out all parts according to the templates. Cut parallel lengthwise slits in each petal, as shown in picture.

2 Bend the petals

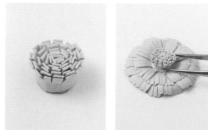

Bend the petals upward (page 39).

3 Curl the petals

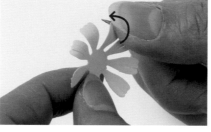

Curl the ends of the petals outward (page 39).

4 Stack and glue cutouts

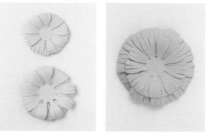

Stack same-sized cutouts together, alternating petals. Place the smaller cutouts on top of the larger ones and glue all (page 42).

5 Make the stamen

Make a double-fringed stamen as shown on page 43, spreading the fringe outward. Glue the stamen in the center of the flower.

6 Add the leaf and sepal

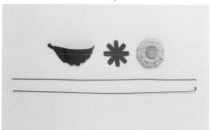

Apply glue to the base of the leaf and wrap it partway around the end of one stem to secure. Attach the sepal to the other stem as shown on page 46.

7 Final touches

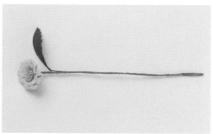

When the glue has dried, glue the flower to the sepal. Wrap the flower stem and leaf stem together with floral tape (page 46).

Anemone [see photo page 7]

Flower size: ~ 2-in (5-cm) diameter

MATERIALS (FOR ONE FLOWER)

Petals ●
 page 91, template 91-1—2 pieces

Stamen ●
 ³⁄₁₆ x 11¾ in (0.5 x 30 cm)—1 piece
 ¾ x 11¾ in (2 x 30 cm)—1 piece

Sepal ●
 page 94, Sepal D template—1 piece

Stem: paper-covered wire—1 piece

1 Prepare the pieces

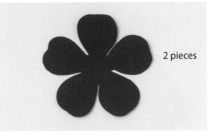

2 pieces

Make the petal and sepal cutouts according to the templates.

2 Curl the petals

 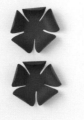

On both petal cutouts, curl the ends in (page 41).

3 Stack and attach

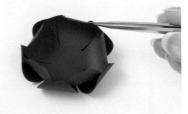

Stack and glue the petal cutouts, alternating the petals (page 42).

4 Make the stamen

Make a simple stamen (page 44) using a ³⁄₁₆ in (0.5 cm) wide strip. Then make a double-fringed stamen (page 43) using a ¾-in (2-cm) strip and roll it around the simple stamen. Glue to secure.

5 Attach the stamen

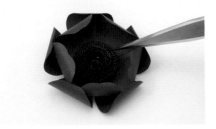

Glue the stamen to the center of the flower.

6 Add the sepal and finish

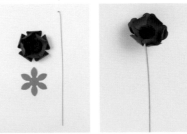

Prepare the sepal and stem parts. Attach the sepal to the stem, then glue the flower to the sepal (page 46). Your Anemone is complete!

 TIP Press the stamen against your finger while rolling to keep the ends even.

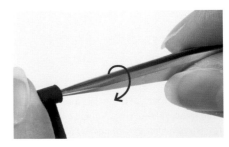

Carnation [see photo page 7]

Flower size: ~ 2¼-in (6-cm) diameter

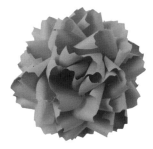

MATERIALS (FOR ONE FLOWER)

Petals ●
 page 91, template 91-2—7 pieces
Sepal ●
 page 95, Sepal F template—1 piece
Stem: paper-covered wire—1 piece

1 Prepare the pieces

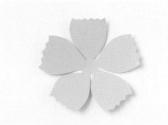

Cut all parts according to the templates.

2 Curl the petals

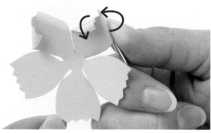

Use the craft stylus to curl each petal diagonally, alternating inward and outward curls (page 41).

3

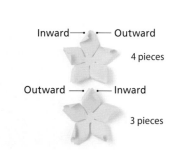

Inward → ← Outward

4 pieces

Outward → ← Inward

3 pieces

Curl the petals of four cutouts inward on the left and outward on the right. Reverse this on the other three cutouts as shown.

4 Stack and attach

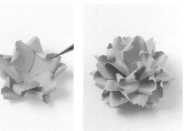

Stack two cutouts together, alternating petal position and curl direction, and glue together. Stack and glue alternate pairs.

5 Make the center petals

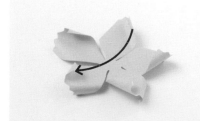

Take the leftover petal cutout and apply glue to an outward-curling corner. Attach it to an inward-curling corner of the petal on the opposite side.

6

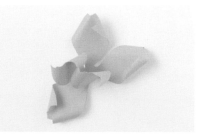

After gluing, the center petals should look like this.

7 Secure the center petals

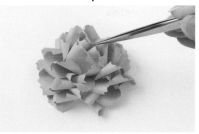

Attach the remaining piece to the center of the flower.

8 Attach the sepal

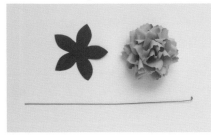

Prepare the sepal and stem as shown on page 46. Attach the sepal to the stem.

9 Finish

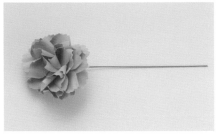

Glue the flower to the sepal. Your Carnation is complete!

English Daisy

[see photo page 8]

Flower size: ~ 1⅜-in (3.5-cm) diameter

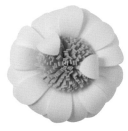

MATERIALS (FOR ONE FLOWER)

Petals ○
 page 92, template 92-7—3 pieces
Stamen ●
 ¾ x 8 in (2 x 20 cm)—1 piece
Patching piece ○
 page 94, Sepal H template—1 piece
Leaf ●
 page 95, Leaf D template—5 pieces
Stem: paper-covered wire—6 pieces, floral tape

1 Prepare the pieces

3 pieces

Cut out all parts according to the templates.

2 Curl the petals

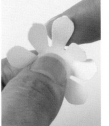
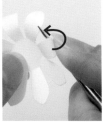

Bend all the petal bases inward, then bend the edges out (page 39). Do this for all three cutouts.

3 Stack and attach

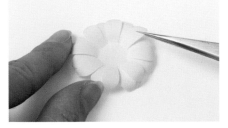

Stack all the parts together, alternating the petals (page 42).

4 Create the stamen

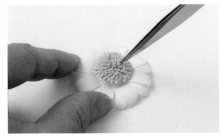

Make a double-fringed stamen as shown on page 43. Gently open the fringes outward with your fingers.

5 Curl the petals

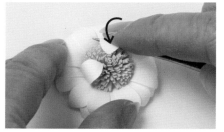

Take a couple petals and curl them inward (page 41).

6 Prepare the leaf and stem

Crease the leaf as shown on page 45. Prepare the stem (page 46).

7 Final touches

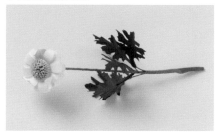

Attach the patch to the stem in place of a sepal (refer to Tip 2 on page 56). When it has dried, wrap the leaf and stem together with the floral tape (page 47).

SHASTA DAISY

The Shasta Daisy is just a variation of the English Daisy. The stamen is different.

[**Stamen**: page 95, Stamen A template—3 pieces]

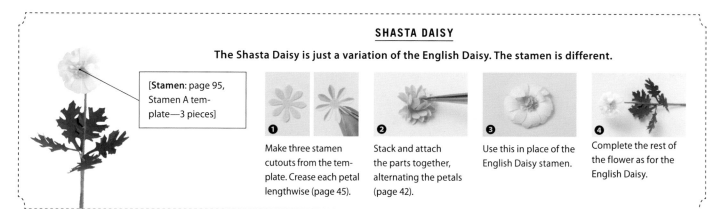

❶ Make three stamen cutouts from the template. Crease each petal lengthwise (page 45).

❷ Stack and attach the parts together, alternating the petals (page 42).

❸ Use this in place of the English Daisy stamen.

❹ Complete the rest of the flower as for the English Daisy.

Tulip [see photo page 8]

Flower size: ~ 1⅜-in (3.5-cm) diameter

MATERIALS (FOR ONE FLOWER)

Petals ●
 page 91, template 91-3—2 pieces
Stamen: white floral pips
Patching Piece ●
 page 94, Sepal H template—1 piece
Leaf ●
 page 95, Leaf B template—1 piece
Stem: paper-covered wire—1 piece

1 Prepare the pieces

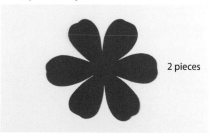

2 pieces

Cut out all parts according to the templates.

2 Shape the petals

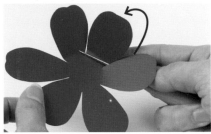

Bend the petals inward (page 41).

3 Curl the petals

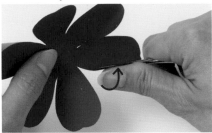

Curl the sides of each petal inward (page 40). Do this for both cutouts.

4 Dot petals with glue

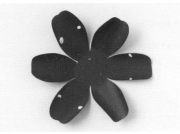

Apply a dab of glue to the sides of alternate petals on one cutout.

5 Bring the petals together

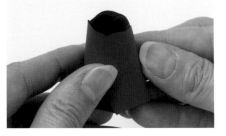

Bring the petals together and make a cylinder.

6 Add second cutout

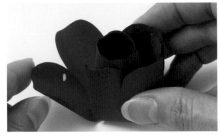

Apply glue to the second petal cutout as shown in step 4. Bend the petals up around the first cutout and glue as shown.

7 Attach the stamen

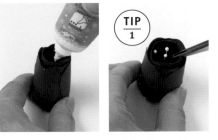

Apply glue to the center of the flower. Use tweezers to attach the floral pips to the center.

8 Prepare the stem

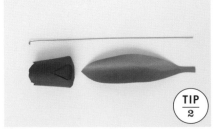

Prepare the stem (page 46). Use the patch in place of a sepal. When it has dried, glue the flower to the patch.

9 Final touches

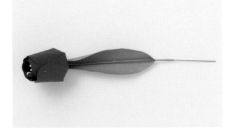

Apply glue to the inside base of the leaf. Fold the leaf around the stem to attach. Your Tulip is complete!

TIP 1 Let the glue dry enough to be tacky before attaching the floral pips.

TIP 2 Since the tulip is a flower without a sepal, a patching piece the same color as the flower will be used to attach the flower to the stem. Refer to instructions for attaching the sepal on page 46.

Gerbera Daisy

[see photo page 8]

Flower size: ~ 1¾-in (4.5-cm) diameter

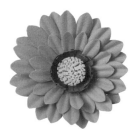

MATERIALS (FOR ONE FLOWER)

Petals ●
 page 92, template 92-10—3 pieces
 page 92, template 92-8—2 pieces
●
 page 92, template 92-9—2 pieces

Stamen ●
 ⅜ x 6 in (1 x 15 cm)—1 piece

Sepal ●
 page 95, Sepal F template—1 piece

Stem: paper-covered wire—1 piece

1 Prepare the pieces

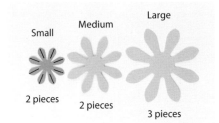

Cut out all pieces according to the templates. Use scissors to make lengthwise cuts in the smallest petal cutouts as shown in the photo.

2 Curl the outer petals

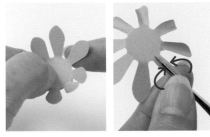

Bend the petals of the medium and large cutouts inward. Turn over and curl each petal around the stylus lengthwise (page 40).

3 Crease the outer petals

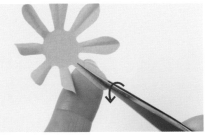

Turn the cutouts over again and add a lengthwise crease to each petal (page 45).

4 Curl the innermost petals

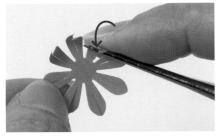

Curl the petals of the smallest cutouts inward (page 41).

5 Stack and attach

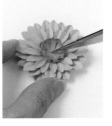

Stack and glue same-sized cutouts together, alternating the petals.

6 Create the stamen; attach the sepal

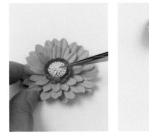

Make a double-fringed stamen (page 43) and attach to the center of the flower. Cut out the sepal, and attach it to the stem, then attach the flower (page 46).

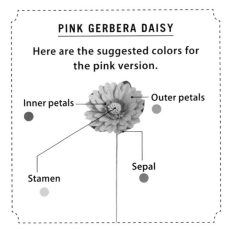

PINK GERBERA DAISY

Here are the suggested colors for the pink version.

Inner petals

Outer petals

Stamen

Sepal

Madonna Lily

[see photo page 9]

Flower size: ~ 1½-in (4-cm) diameter;
1¼-in (3-cm) height

MATERIALS (FOR ONE FLOWER)

Petals ○
 page 92, template 92-11—6 pieces
Stamen Yellow floral pips
Patching piece ○
 page 95, Sepal G template—1 piece
Leaf ●
 page 95, Leaf B template—1 piece
Stem: paper-covered wire—2 pieces, floral tape

1 Prepare the pieces

6 pieces

Cut out all pieces according to the templates.

2 Add creases to the petals

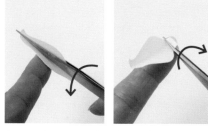

Crease the center of each petal lengthwise (page 45). Use tweezers to fold the base in.

3 Curl the petals

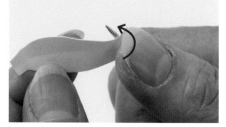

Curl the tips outward (page 39). Repeat steps 2 and 3 with all six petals.

4 Stack and attach

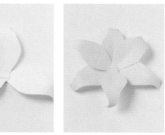

Glue 3 petals together at the base, then do the same to the remaining 3 petals. Stack and glue the 2 pieces together, alternating the petals.

5 Lift and glue petals

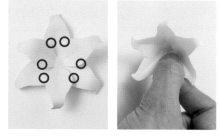

Apply some glue to the bottom three petals as indicated by the red circles. Lift and glue adjacent petals to add dimension.

6 Attach the stamen

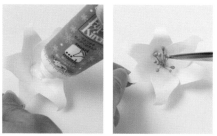

Apply a generous amount of glue to the center of the flower. Let it dry slightly, then set the floral pips in for the stamen.

7 Attach the leaf; final touches

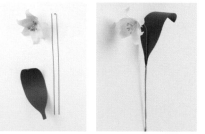

Curl the tip of the leaf outward. Glue the leaf to one stem. Prepare the other stem (page 46) and attach it to the patch in place of the sepal (refer to Tip 2 on page 56). Secure the stems together with floral tape.

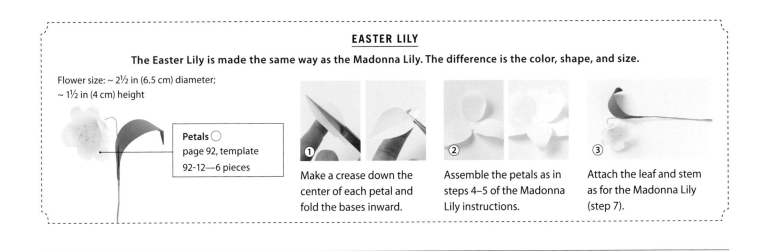
Hydrangea

[see photo page 9]

Flower size: ~ 1-in (2.5-cm) diameter

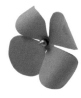

MATERIALS (FOR ONE CLUSTER)

Petals ●
page 94, template 94-1—8 pieces

●
page 94, template 94-1—7 pieces

Stamen: Liquid Pearls (silver)

Leaf ●
page 95, Leaf C template)—3 pieces

Stems: paper-covered wires—18 pieces, floral tape

1 Prepare the pieces

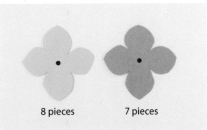

8 pieces 7 pieces

Cut out all pieces according to the templates. Use the tracing stylus to poke a hole in the center of each cutout.

2 Curl the petals

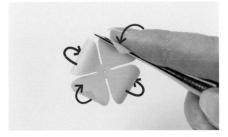

Curl the tips of the petals out, then make random curls (page 41).

3 Prepare and insert stems

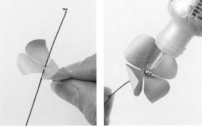

Coil and bend stem ends (page 46). Carefully poke a stem through the hole at the center of a flower and pull the stem all the way through. Place a dot of Liquid Pearls at the center and let dry. Repeat these steps for all petal cutouts.

4 Assemble leaves; final touches

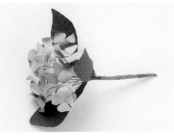

Attach the leaves to stems with floral tape, then bundle all stems together (page 47). Your Hydrangea is complete!

Pacino Sunflower [see photo page 10]

Flower size: ~ 2-in (5-cm) diameter

MATERIALS (FOR ONE FLOWER)

Petals ●
 page 93, template 93-4—4 pieces

Stamen ●
 ³⁄₁₆ x 11¾ in (0.5 x 30 cm)—1 piece
 ⅜ x 11¾ in (1 x 30 cm)—1 piece

Sepal ●
 page 94, Sepal E template—1 piece

Leaf ●
 page 95, Leaf E template—1 piece

Stem: paper-covered wire—2 pieces, floral tape

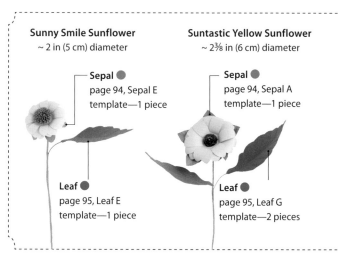

Sunny Smile Sunflower
~ 2 in (5 cm) diameter

Sepal ●
page 94, Sepal E
template—1 piece

Leaf ●
page 95, Leaf E
template—1 piece

Suntastic Yellow Sunflower
~ 2⅜ in (6 cm) diameter

Sepal ●
page 94, Sepal A
template—1 piece

Leaf ●
page 95, Leaf G
template—2 pieces

1 Prepare the pieces

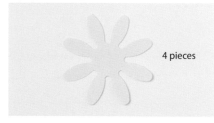

4 pieces

Cut out all pieces according to the templates.

2 Curl the petals

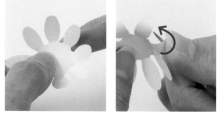

Bend the petals in at the base, then curl the ends out (page 39).

3 Stack and attach

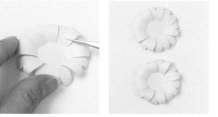

Stack two cutouts and glue them together, alternating the petals. Then glue the two pairs together (page 42).

4 Create the stamen

 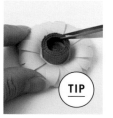

TIP

Make a simple stamen (page 44) with the ³⁄₁₆-in (0.5-cm) wide strip. Make a single-fringe stamen (page 44) from the ⅜-in (1-cm) wide strip. Wrap the fringed strip around the simple stamen and seal with glue.

5 Cross-curl three petals; prepare the leaf and stems

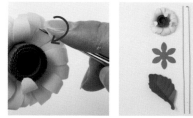

Curl in 3 petals inward (page 41). Make creases in the leaf (page 45). Prepare the flower stem and sepal (page 46). Attach the leaf to the other stem.

6 Final touches

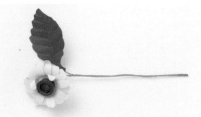

Attach the flower to the sepal (page 46). Bundle the stems together with floral tape (page 47). Your Pacino Sunflower is complete!

SUNNY SMILE SUNFLOWER, SUNTASTIC YELLOW SUNFLOWER

The three types of sunflowers are basically the same, but there are variations in the shape of the petals, stamen, leaves, etc.

Sunny Smile Sunflower

Stamen ●
¾ x 8 in (2 x 20 cm)—1 piece

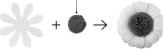 + ● → ●

The petal shape and color are the same as for the Pacino Sunflower. Follow steps 1–2 to make the petals. Make a double-fringed stamen (page 43).

Suntastic Yellow Sunflower

Petals ●
page 93, template 93-5—3 pieces

Stamen ● & ●
⅝ in (1.5 cm) diameter— 7 pieces

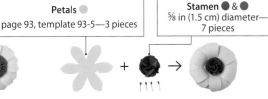

Curl the petals as for other sunflowers. Follow the steps at right to make the stamen, then attach tiny brown floral pips to the center.

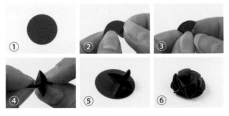

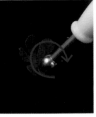

Use one of the 7 circles as the base ①. For the remaining 6 pieces, fold four times ②–③, then make a cross-like shape ④. Apply glue and use tweezers to glue the parts to the base ⑤–⑥.

Lavender [see photo page 10]

Flower size: ~ ⅜-in (1-cm) diameter

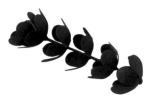

MATERIALS (FOR ONE CLUSTER)

Petals ●
> page 92, template 92-13—18 pieces

●
> page 92, template 92-13—18 pieces

Stems: paper-covered wire—6 pieces, floral tape

1 Prepare the pieces; bend the petals

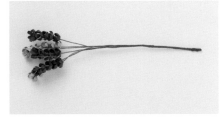

18 pieces

18 pieces

Use the templates to cut out all petals. Make a hole at the center of 15 of the flower cutouts of each color, leaving 3 of each color intact. Use an embossing pen to bend the flowers inward.

2 Add the stem

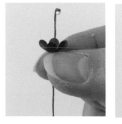

¾₆ in (5 mm)

Make a ⅛-in (3-mm) bend at the very end of each stem. Thread five flowers of the same color onto each stem, leaving about a ³⁄₁₆-in (5-mm) interval between each flower. Use glue to keep each flower at its position.

3

Matching the colors, glue a flower cutout without a hole to the top of each stem.

4 Final touches

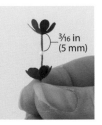

Bundle the stems together with floral tape (page 47). Your Lavender is complete!

Cosmos

[see photo page 11]

Flower size: ~ 1¾-in (4.5-cm) diameter

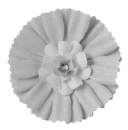

MATERIALS (FOR ONE FLOWER)

Petals ◯
 page 91, template 91-4—3 pieces

Stamen ◯
 page 95, Stamen C template—2 pieces

 page 95, Stamen B template—2 pieces

Clear rhinestone

Sepal ●
 page 95, Sepal F template—1 piece

Stem: floral wire—1 piece, floral tape

1 Prepare the pieces

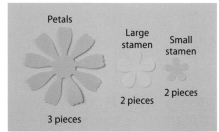

Cut the parts out according to the templates.

2 Curl the petals

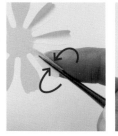

After folding each petal inward lengthwise as shown, use your fingers to curl the corners outward (page 41).

3 Stack and attach the petals

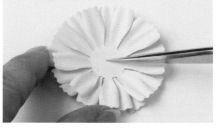

Stack and glue all three flower cutouts, alternating the petals (page 42).

4 Curl the stamen petals

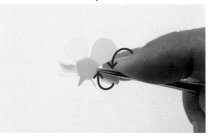

For each of the stamen cutouts, bend the petals inward at the base, then curl the sides inward (page 40).

5 Stack same-sized stamens

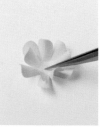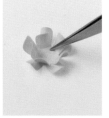

Stack and glue the same-sized stamen cutouts.

6 Attach stamens to flower

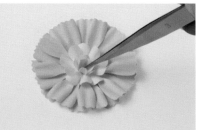

Glue the larger stamen stack to the petals, then glue the smaller stamen stack on top.

7 Add the rhinestone

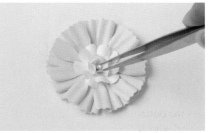

Glue the rhinestone in the center of the flower.

8 Add the stem

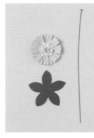

Prepare the sepal and stem. Attach the completed flower to the sepal (page 46).

WHITE COSMOS

Use these materials for a white variation of the cosmos.

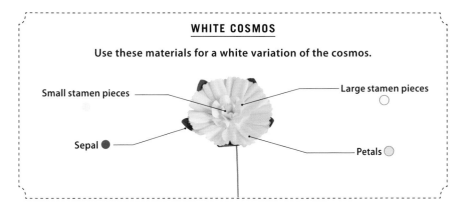

Small stamen pieces

Large stamen pieces ○

Sepal ●

Petals ○

Lisianthus

[see photo page 11]

Flower size: ~ ⅜-in (1-cm) diameter

MATERIALS (FOR ONE FLOWER)

Petals ●
 page 91, template 91-5—4 pieces
Sepal ●
 page 94, Sepal E template—1 piece
Leaf ●
 page 95, Leaf A template—2 pieces
Stem: floral wire—3 pieces, floral tape

1 Prepare the pieces

4 pieces

Cut out all pieces according to the templates.

2 Curl the petals

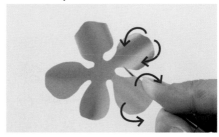

For the bottom cutout, fold the petals inward lengthwise at the center. Curl the sides outward (page 41).

3

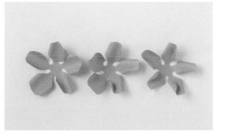

For the other flower cutouts, curl the edges of the petals at random (page 41).

4 Stack and attach

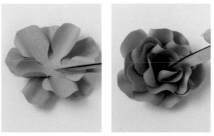

Stack and glue on two of the cutouts from step 3 on top of the bottom cutout. Finally, glue the remaining cutout in the center. Tweezers are helpful in the tight space.

5 Prepare the leaves, stems, and sepal

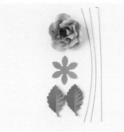

Cut the leaves out according to the template and make creases to both pieces (page 45). Prepare the sepal and stem.

6 Final touches

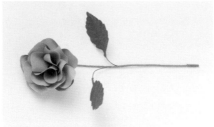

Glue on the flower to the sepal (page 46). Attach the leaves to the stem with floral tape, alternating as shown (page 47).

Dahlia [see photo page 11]

Flower size: ~ 2-in (5-cm) diameter

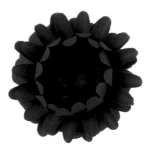

MATERIALS (FOR ONE FLOWER)

Petals ●
 page 93, template 93-6—8 pieces
 page 93, template 93-3—2 pieces
 page 92, template 92-9—2 pieces

Sepal ●
 page 95, Sepal F template—1 piece

Leaf ●
 page 95, Leaf A template—2 pieces

Stem: paper-covered wire—3 pieces, floral tape

1 Prepare the pieces

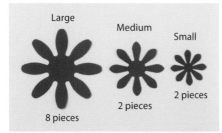

Large
Medium
Small
8 pieces
2 pieces
2 pieces

Cut the parts out according to the template.

2 Curl the petals; stack and attach

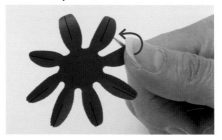

Take three of the larger cutouts and add lengthwise creases (page 45), and then curl the tips outward (page 39). Stack and glue them together, then set them aside.

3

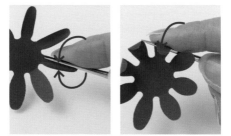

With the remaining large cutouts, fold the petals in from the base (page 39). For three cutouts, fold the sides in lengthwise. Curl the ends of the remaining two cutouts inward (page 41). Stack and glue like-sized cutouts together; set aside.

4

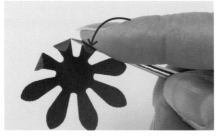

For the medium cutouts, fold the petals inward from the base (page 39), then curl the ends inward (page 41). Stack and glue them together. Repeat the same steps with the smaller cutouts.

5

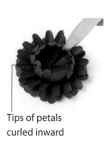

2 petals

Sides of petals curled inward

Tips of petals curled inward

Place the petals from step 3 on top and attach.

6

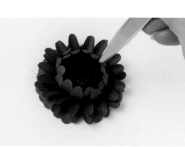

Add the petals from step 4 to the top and attach.

7 Make the leaves and sepal; final touches

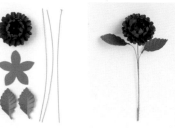

Add creases to the leaves (page 45). Attach the sepal to the stem, and glue on the flower (page 46). Bundle the leaves and stem together with floral tape (page 47).

Damask Rose

[see photo page 12]

Flower size: ~ 2-in (5-cm) diameter

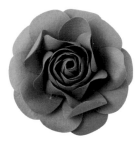

MATERIALS (FOR ONE FLOWER)

Petals ●
page 94, template 94-2—7 pieces

Sepal ●
page 95, Sepal F template—1 piece

Leaf ●
page 95, Leaf A template—3 pieces

Stem: paper-covered wire—4 pieces, floral tape

1 Prepare the pieces

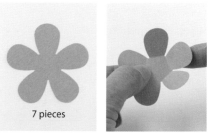

7 pieces

Cut out all pieces according to the templates. Fold up the petals from the base as shown here (page 39).

2 Curl the innermost petals

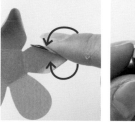

Take one flower cutout and curl the sides of the petals in (page 40). Fold the petals in like a tube and secure with glue.

3 Curl two more cutouts

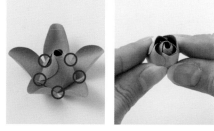

Curl two more cutouts as in step 2. Fold one around the piece from step 2 and secure with glue as shown in the picture.

4 Complete the Rosebud stage

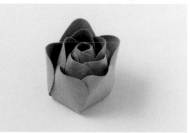

Fold the third cutout around the first two and glue in place as shown above. Now you have a Rosebud (see page 66).

5 Curl another cutout

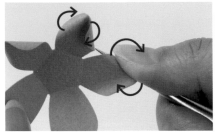

Curl the edges of the fourth cutout at random (page 41).

6 Curl another cutout

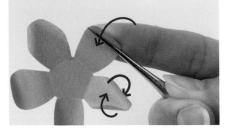

For the fifth cutout, curl the petals at random (page 41), but do it in a different way from the petals in step 5.

7 Curl the bottom cutouts

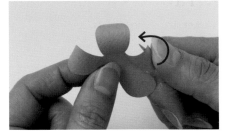

For the remaining two cutouts, curl the tips outward (page 39).

8 Assemble the pieces

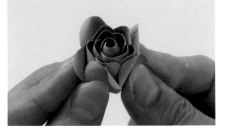

Wrap the piece from step 5 around the rosebud; glue to secure.

9 Add more petals

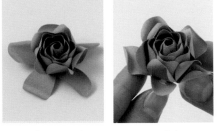

Wrap the piece from step 6 around the rest of the rose; glue to secure.

10 Add the outer petals

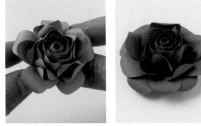

Add the bottom cutouts, gluing each one to secure as shown.

11 Complete leaves and sepal; final touches

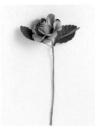
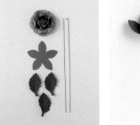

Crease the leaves (page 45) and glue each one to a stem. Attach the sepal to the last stem, then attach the flower (page 46). Secure the leaves to the stem with floral tape.

WHITE ROSE AND ROSEBUD

Colors and templates used for white roses are below.
To make the Rosebud, follow steps 1–4 for the Damask Rose (page 65).

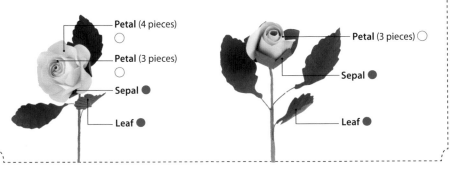

Petal (4 pieces) ○
Petal (3 pieces) ○
Sepal ●
Leaf ●

Petal (3 pieces) ○
Sepal ●
Leaf ●

Grandiflora Rose [see photo page 13]

Flower size: ~ 2-in (5-cm) diameter

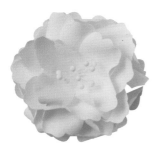

MATERIALS (FOR ONE FLOWER)

Petals ◯
page 93, template 93-2—6 pieces

Stamen: White floral pips

Sepal ●
page 95, Sepal F template—1 piece

Leaf ●
page 95, Leaf A template—3 pieces

Stem: paper-covered wire—4 pieces,
floral tape

1 Prepare the pieces

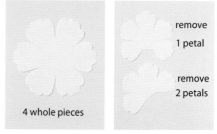

4 whole pieces

remove
1 petal

remove
2 petals

Cut out all parts according to the templates. Keep four of the flower cutouts intact. Remove petals from the other two as shown.

2 Curl the bottom petals

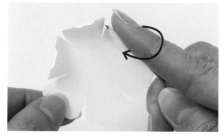

Curl the tips of two of the intact flower cutouts inward (page 41).

3 Curl the other intact petals

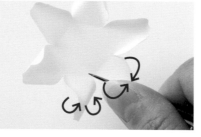

For the other two intact cutouts, bend the petals up from the base (page 39), then curl the sides at random (page 41).

4 Curl the innermost petals

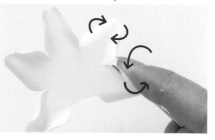

For the flower cutouts with petals removed, curl the sides at random (page 41).

5 Crease and glue the innermost petals

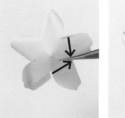

Add creases to the partial cutouts as shown. Glue two opposite petals together on each cutout.

6 Stack and attach the outer petals

Stack the cutouts from step 2 and glue. Do the same with the cutouts from step 3. Then stack and glue the second set to the first.

7 Attach the innermost petals

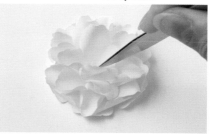

Use tweezers to insert and glue the inner petals from step 5 at the center of the flower.

8 Attach the stamen

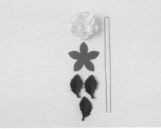

Add a generous amount of glue to the center of the flower and let it dry slightly, then add the floral pips for the stamen.

9 Crease the leaf; add the sepal

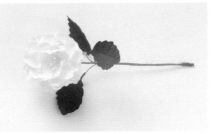

Crease the leaves (page 45) and glue each one to a stem. Prepare the fourth stem and glue the sepal to it (page 46).

10 Final touches

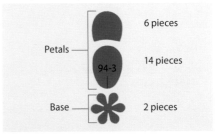

Glue the rose to the sepal. Bundle the leaves and main stem together with floral tape (page 47). Your Grandiflora Rose is complete!

Climbing Rose

[see photo page 13]

Flower size: ~ 2-in (5-cm) diameter

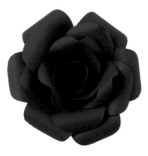

MATERIALS (FOR ONE FLOWER)

Petals ●
 page 94, template 94-3—14 pieces
 page 94, template 94-4—6 pieces
Base ●
 page 94, Sepal H template—2 pieces
Sepal ●
 page 95, Sepal F template—1 piece
Leaf ●
 page 95, Leaf A template—3 pieces
Stem: paper-covered wire—4 pieces, floral tape

1 Prepare the pieces

Cut out the parts according to the templates. Make a ⅛-in (3-mm) slit at the bottom edge of all the 94-3 template cutouts.

2 Prepare the petals

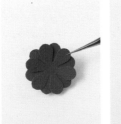

Stack and secure the two base cutouts, alternating the petals. For each of the 94-3 cutouts with the slit at the bottom, fold the resulting flaps down and together.

3 Curl the main petals

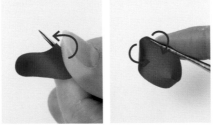

For nine of the 94-3 cutouts, curl the tips outward (page 39). For the other five, turn the petals over and curl the corners. Use the tracing stylus to help with the folds.

4 Prepare the inner petals

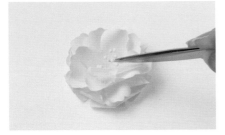

For the six 94-4 cutouts, curl the sides inward. These will be the inner petals of the rose.

5 Organize the petals

Organize the fourteen 94-3 cutouts as shown above. We will refer to these as A, B, and C.

6 Attach the outer petals

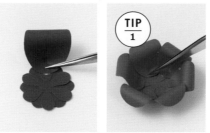

First, glue six of the "A" petals around the base of the rose made in step 2. Allow the glue to dry (see Tip 1).

7 Attach the second layer of petals

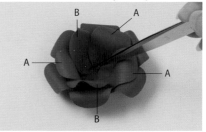

Next, glue the remaining "A" petals as shown above. Follow with the two "B" petals. Allow the glue to dry.

8 Attach the third layer of petals

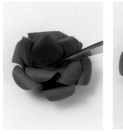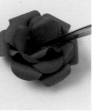

Glue the three "C" petals next. Allow the glue to dry.

9 Attach the inner petals

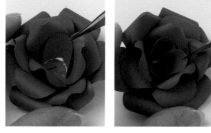

Now add the 94-4 petals (see Tip 2). Apply glue to the base of each petal and use tweezers to affix them inside the flower.

10

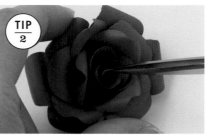

This is how the rose looks after gluing on all six of the 94-4 petals.

11 Add the leaves; prepare the sepal

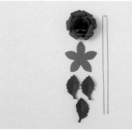

Add creases to the leaves (page 45) and glue them to the stems. Prepare the remaining stem and attach the sepal.

12 Final touches

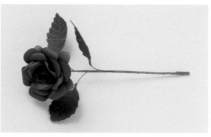

Glue the rose to the sepal. Use floral tape to bundle the leaves and stem together. Your Climbing Rose is complete!

TIP 1 Build the rose a few petals at a time, allowing the glue to dry a little each time. Allow the glue to dry fully between steps for best results.

TIP 2 The space for the petals will become very narrow, so roll the last few petals into a cone shape and use tweezers to insert them into the rose.

Hybrid Tea Rose [see photo page 13]

Flower size: ~ 1¼-in (3-cm) diameter

MATERIALS (FOR ONE FLOWER)

Petals ○
page 93, template 93-7—1 piece

Sepal ●
page 94, Sepal H template—1 piece

Leaf ●
page 95, Leaf F template—3 pieces

Stem: paper-covered wire—4 pieces,
floral tape

1 Prepare the pieces

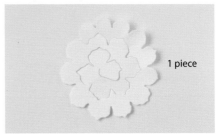

1 piece

Cut out all parts according to the templates.

2 Roll the petals

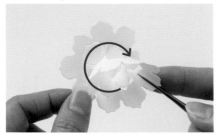

The petals at the center of the template
will be the inner part of the rose. Hold with
tweezers and roll clockwise as shown.

3

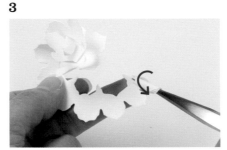

Roll the next section of petals as shown,
leaving the last four to be the base of the
flower. Let the petal tips angle outward.

4 Stack and attach

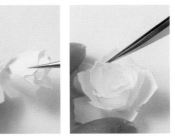

Set the rolled petals on the four base petals.
Use a generous amount of glue to secure.
Once the glue has dried slightly, adjust the
petals to your liking.

5

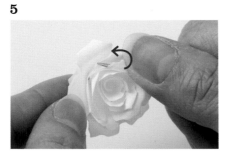

Once the glue is completely dry, curl the
outer petals outward (page 39).

6 Make the leaves, sepal, final touches

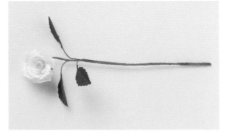

Glue the leaves to the stems and attach the
sepal to the remaining stem. Use floral tape
to bundle all stems together (pages 46–47).

TEA ROSE VARIATIONS

**Try making tea roses in
different colors!**

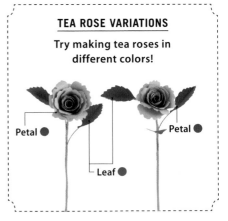

Petal ●

Petal ●

Leaf ●

Pom Pom Chrysanthemum [see photo page 14]

Flower size: ~ 2-in (5-cm) diameter

MATERIALS (FOR ONE FLOWER)

Petals ○

 page 93, template 93-8—7 pieces

Sepal ●

 page 94, Sepal E template—1 piece

Stem: paper-covered wire—1 piece

1 Prepare the pieces

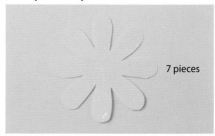

7 pieces

Cut out all parts according to the templates.

2 Prepare the inner petals

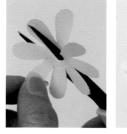

Make a cut to the middle of one of the petal cutouts. Cut out a circle at the center. This will form the innermost petals.

3 Curl the petals

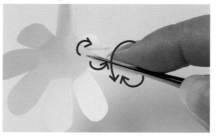

For the other six petal cutouts, fold the petals in from the base and curl the petals lengthwise, alternating inward and outward curls (see page 40).

4 Stack and attach

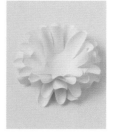

Stack and glue the cutouts two at a time, alternating petals. Then glue the three stacks together (page 42).

5 Roll up the inner petals

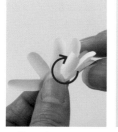

Roll up the inner petal cutout from step 2 into a cone shape. Seal with glue.

6 Attach the inner petals

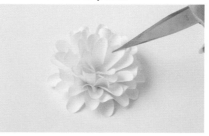

Use tweezers to glue it to the center of the stack of petals.

7 Add the sepal and stem

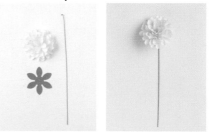

Prepare the stem and add the sepal (page 46). Glue the flower to the sepal. Your Pom Pom Chrysanthemum is complete!

Semi-Double Chrysanthemum [see photo page 14]

Flower size: ~ 2-in (5-cm) diameter

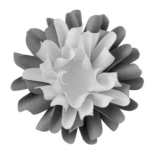

MATERIALS (FOR ONE FLOWER)

Petals ⚪
 page 94, template 94-5—5 pieces
 🔴
 page 94, template 94-5—3 pieces
 🔴
 page 94, template 94-6—2 pieces
Sepal 🔴
 page 95, Sepal C template—1 piece
Stem: paper-covered wire—1 piece

1 Prepare the pieces

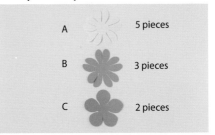

A		5 pieces
B		3 pieces
C		2 pieces

Cut out all parts according to the template. The white 94-5 cutouts are "A," the pink 94-5 cutouts are "B," and the 94-6 cutouts are "C."

2 Cut the inner petals

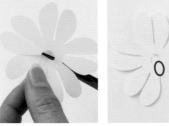

For two "A" petals, make a cut to the middle and cut a circle at the center as shown. Apply glue to the point shown above.

3 Combine the inner petals

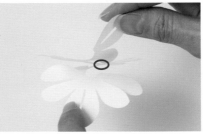

Glue the two cutouts end to end as shown to make a long spiral. This will form the inner petals.

4 Curl the main petals

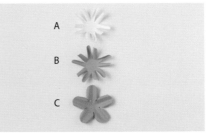

For the C petals, bend the petals in, then curl the sides outward (page 41). For remaining three A petals and the B petals, bend in and curl the sides inward (page 40).

5 Roll up the inner petals

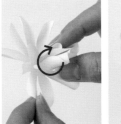

For the piece from step 3, start at one end and roll clockwise to make a cone shape. Seal the end with glue.

6 Assemble the flower

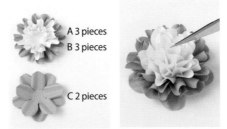

A 3 pieces
B 3 pieces
C 2 pieces

Stack and attach like cutouts as shown above. Then glue the stacks together with the C petals at the base, then B, then A. Finally, using tweezers, glue the rolled piece from step 5 to the center.

7 Add the sepal and stem

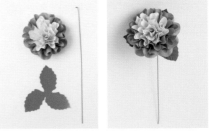

Crease the sepal as you would a leaf (see page 45). Prepare the stem and attach the sepal, then glue on the flower (page 46).

Poinsettia [see photo page 14]

Flower size: ~ 2¾-in (7-cm) diameter

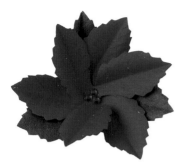

MATERIALS (FOR ONE FLOWER)

Petals ●
 page 95, Leaf A template—6 pieces
Stamen: red rhinestones—3 pieces
Sepal ●
 page 94, Sepal E template—1 piece
Leaves ●
 page 95, Leaf A template—3 pieces
Stem: paper-covered wire—1 piece

1 Prepare the pieces; add creases; curl the petals

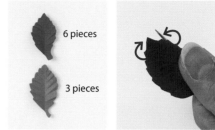

Cut out all parts according to the templates. Crease petals and leaves as described on page 45. Curl the sides of the petals outward (page 40).

2 Stack and attach the petals

Glue three petals together at their bases as shown. Glue the remaining three petals on top.

3 Add the leaves and stamen

Turn the flower over and attach the leaves as shown. Attach the rhinestones to the center of the flower.

4 Add the sepal

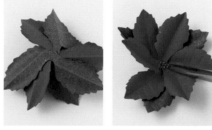

Prepare the stem and add the sepal (page 46). Your Poinsettia is complete!

Camellia [see photo page 15]

Flower size: ~ 2-in (5-cm) diameter

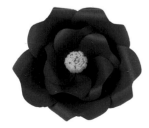

MATERIALS

Petals ●
 page 94, template 94-7—5 pieces
 page 94, template 94-8—5 pieces
Base ●
 page 95, Sepal G template—2 pieces
Stamen ○
 ⅝ x 4 in (1.5 x 10 cm)—1 piece
Patching piece ●
 page 94, Sepal H template—1 piece
Leaves ●
 page 95, Leaf H template—2 pieces
Stem: paper-covered wire—3 pieces, floral tape

1 Prepare the pieces

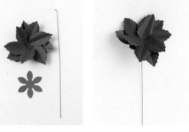

Large petals Small petals Base
5 pieces 5 pieces 2 pieces

Cut the parts out according to the template. Make a ⅛-inch (3-mm) slit in the base of each petal as shown.

2 Stack the base pieces

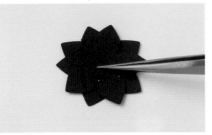

Stack the base pieces and glue them together, alternating the petals.

3 Curl the petals

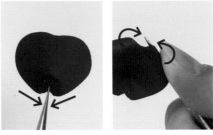

For all petals, fold in the flaps on either side of the slit as shown above. Then curl the edges outward (page 40).

4 Stack and attach

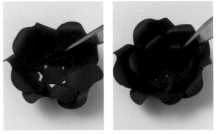

Glue the large petals around the base for the outer flower. When the glue has dried, glue the smaller petals to make an inner layer.

5 Create the stamen

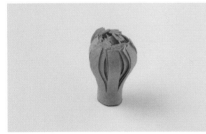

Make a single-fringe stamen (page 44). Use your fingers to shape the fringe like a bulb.

6 Create the stamen, leaves, and stem

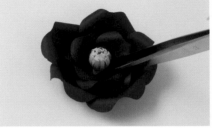

Glue the stamen to the flower. Glue each leaf to a stem. Coil the end of the third stem and add a patching piece in place of a sepal (see Tulip instructions on page 56).

7 Final touches

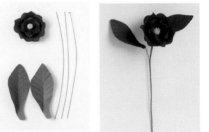

Glue the flower to the patching piece. Use floral tape to bundle the leaves and flower stem together (page 47). Your Camellia is complete!

Plum Blossoms [see photo page 15]

Flower size: ~ 1⅜-in (3.5-cm) diameter

MATERIALS (FOR THREE FLOWERS)

Petals ●
 page 92, template 92-15
 —1 piece
●
 page 92, template 92-15
 —1 piece
○
 page 92, template 92-15
 —1 piece

Stamens ○
 page 95, Sepal D template—
 3 pieces
Small white floral pips
Sepals ●
 page 94, Sepal E template—
 3 pieces
Stems: paper-covered wire—
 3 pieces, floral tape

1 Prepare the pieces

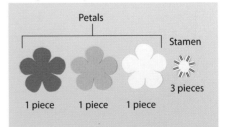

Cut out all parts according to the templates. Make two ¼-in (6-mm) slits down the center of each stamen petal, as shown here.

2 Shape the petals

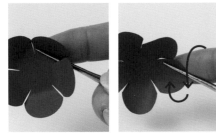

Use the tracing stylus to bend the petals in, then curl the side edges inward.

3 Glue the flower and add the stamen

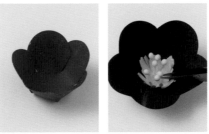

Glue the edges of the petals together to make a cup shape. Bend the petals of the stamen inward. Glue the stamen at the center of the flower, then glue in the floral pips.

4 Add the sepal; final touches

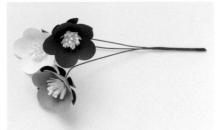

Repeat steps 1–3 with other paper colors. Prepare the sepals and stems (page 46). Attach the flowers to the sepals. Bundle the flowers together with floral tape (page 47).

Cherry Blossoms [see photo page 15]

Flower size: ~ 1-in (2.5-cm) diameter

MATERIALS (FOR THREE FLOWERS)

Petals ◯
 page 92, template 92-14—1 piece
 ◯
 page 92, template 92-14—1 piece
 ●
 page 92, template 92-14—1 piece

Stamens: clear beads—3 pieces
Sepals ●
 page 95, Sepal G template—3 pieces
Stems: paper-covered wire—
 3 pieces, floral tape

1 Prepare the pieces

Cut out all pieces according to the templates.

2 Curl the petals

Use the tracing stylus to make a lengthwise crease down the center of each petal. Lift each petal inward, then curl the edges outward (page 40).

3 Attach the stamen

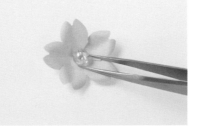

Glue a clear bead at the center of the flower.

4 Add the sepal; final touches

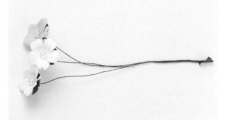

Repeat steps 1–3 with other paper colors. Prepare the sepals and stems (page 46). Attach the flowers to the sepals. Bundle the flowers together with floral tape (page 47).

Making Arrangements and Accessories

BASIC FINDINGS

Here are some materials needed to put together accessories.

HOW TO OPEN A ROUND CHAIN RING

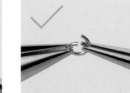

Metal jump ring
The size and thickness of the rings may differ depending on what you are making.

Don't pull the ends of the ring apart to open it. This makes it difficult to close, and you could drop it.

Use needle-nose pliers to open the ring by offsetting the ends.

Eye pin
The loop at the end is what makes this pin so useful. Often used to connect similar parts together.

Head pin
Used to string beads together. The beaded decorations on a few of the paper-flower arrangements in this book call for head pins.

HOW TO USE THE PINS

1

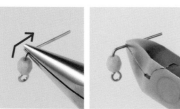

String a bead onto the eye pin. Cut off the excess wire, leaving about ¼ in (6 mm).

2

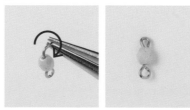

Coil the straight end into a loop, ending it flush with the bead.

BASIC TOOLS

These are basic tools you need to handle the findings.

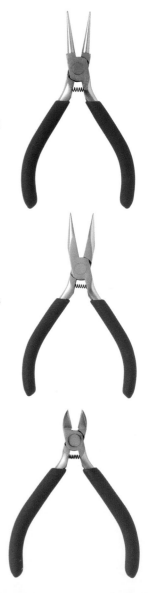

Round-nose pliers
These are especially useful when bending metal pins into a loop, as well as for opening and closing a chain ring.

Chain-nose pliers
The flat side of these pliers makes them especially useful. You can use it to bend an eye pin or head pin, to thread a cord through a hole, and to open or close a jump ring.

Side-cutting pliers
Use these to cut off the ends of eye pins or head pins.

Wreath 1

The Rose-Bearer [see photo page 16]

FLOWERS USED ※ Damask Roses without the sepal and stem,
and Lily of the Valley without the stem

Damask Rose
> **page 65**

Rosebud
> **page 66**

Lily of the Valley
> **page 49**

MATERIALS (FOR ONE WREATH)

*Enlarge Damask Rose templates by 125%

Damask Rose ○—9 flowers; ○ & ●—4 flowers;
●—2 flowers
Rosebud ●—3 flowers
Lily of the Valley ● & ● & ●—15 clusters
Leaves: page 95, Leaf A template ●—12 leaves;
●—13 leaves

Wreath base (8-in / 20-cm diameter)—1 piece
Green tulle or craft netting (2⅜ x 2⅜ in / 6 x 6 cm)
—as needed
Hemp string—as needed

ASSEMBLY

1 Glue the flowers to the wreath base as shown.
2 Glue the leaves toward the outside of the wreath
in a balanced fashion.
3 Fill the spaces between the flowers with the tulle.

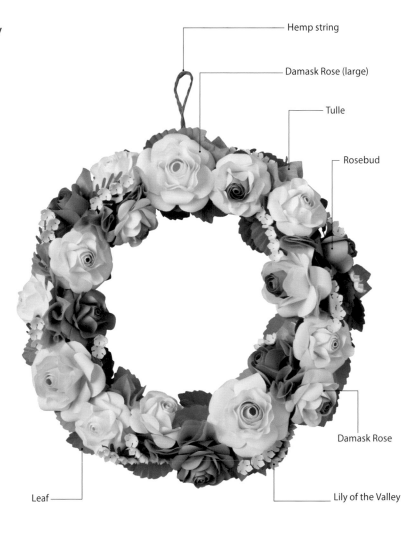

Hemp string

Damask Rose (large)

Tulle

Rosebud

Damask Rose

Lily of the Valley

Leaf

Wreath 2

Flowers in Wonderland [see photo page 17]

FLOWERS USED ※ Make all the flowers without the sepal and stem, except for the lily of the valley, keep the flowers together with the sepal.

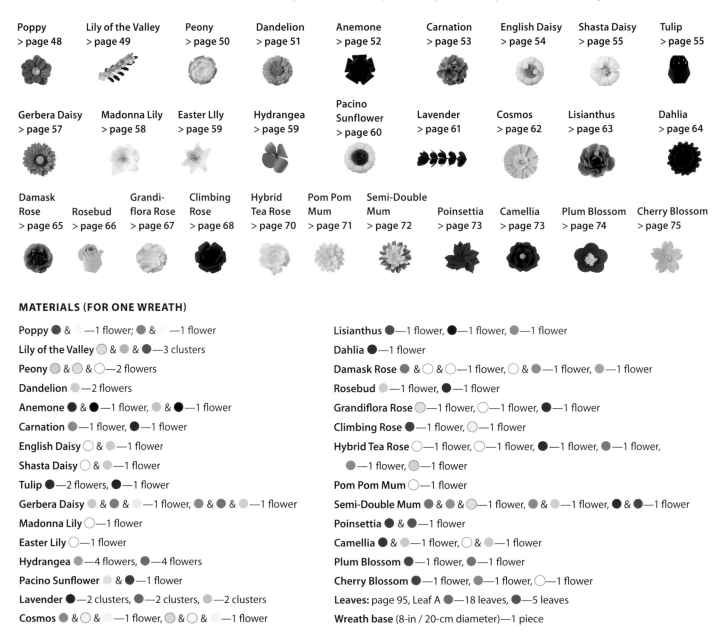

MATERIALS (FOR ONE WREATH)

Poppy ● & ○—1 flower; ● & ○—1 flower

Lily of the Valley ○ & ● & ●—3 clusters

Peony ○ & ○ & ○—2 flowers

Dandelion ●—2 flowers

Anemone ● & ●—1 flower, ● & ●—1 flower

Carnation ●—1 flower, ●—1 flower

English Daisy ○ & ●—1 flower

Shasta Daisy ○ & ●—1 flower

Tulip ●—2 flowers, ●—1 flower

Gerbera Daisy ● & ● & ○—1 flower, ● & ● & ●—1 flower

Madonna Lily ○—1 flower

Easter Lily ○—1 flower

Hydrangea ●—4 flowers, ●—4 flowers

Pacino Sunflower ○ & ●—1 flower

Lavender ●—2 clusters, ●—2 clusters, ●—2 clusters

Cosmos ● & ○ & ○—1 flower, ○ & ○ & ○—1 flower

Lisianthus ●—1 flower, ●—1 flower, ●—1 flower

Dahlia ●—1 flower

Damask Rose ● & ○ & ○—1 flower, ○ & ●—1 flower, ●—1 flower

Rosebud ●—1 flower, ●—1 flower

Grandiflora Rose ○—1 flower, ○—1 flower, ●—1 flower

Climbing Rose ●—1 flower, ○—1 flower

Hybrid Tea Rose ○—1 flower, ○—1 flower, ●—1 flower, ●—1 flower, ●—1 flower, ○—1 flower

Pom Pom Mum ○—1 flower

Semi-Double Mum ● & ● & ○—1 flower, ● & ●—1 flower, ● & ●—1 flower

Poinsettia ● & ●—1 flower

Camellia ● & ●—1 flower, ○ & ●—1 flower

Plum Blossom ●—1 flower, ●—1 flower

Cherry Blossom ●—1 flower, ●—1 flower, ○—1 flower

Leaves: page 95, Leaf A ●—18 leaves, ●—5 leaves

Wreath base (8-in / 20-cm diameter)—1 piece

HOW TO MAKE

1 Glue the flowers to the wreath base. Cover up the base as much as possible.
2 Balance the arrangement by adding leaves to parts that are uncovered.

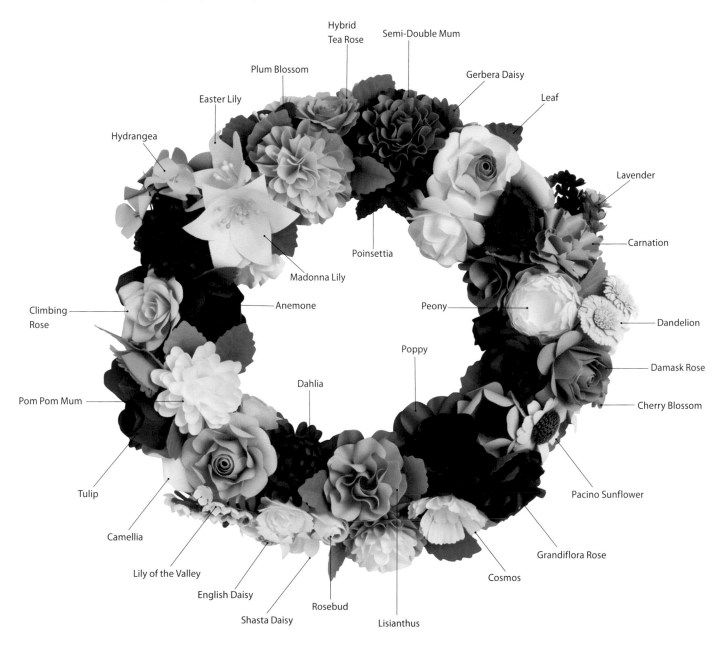

Flower Lamp

And the Stars Were Shining [see photo page 18]

FLOWERS USED ※ Make the flower without the sepal or stem.

Lisianthus
> **page 63**

Damask Rose
> **page 65**

Grandiflora Rose
> **page 67**

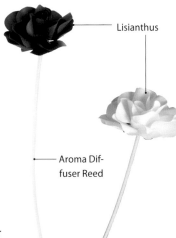

MATERIALS (FOR ONE STRING)

Lisianthus ○—6 flowers
Damask Rose ○—7 flowers
Grandiflora Rose ○—7 flowers

LED light string (20 bulbs, 9.8 feet / 3 m)—1 piece

ASSEMBLY

Make a square hole in the bottom of each flower and push the bulb through (see "Tip" at right).

TIP

Attaching flowers to LED bulbs

When making each flower, create a square hole just large enough for the light bulb to fit through. The flower won't stay as well if the hole is round, so a square is recommended.

Aroma Diffuser

The Dowager [see photo page 19]

FLOWERS USED

※ Make the flower without the stem

Lisianthus
> **page 63**

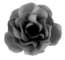

MATERIALS (FOR ONE)

BLUE AROMA FLOWER
Lisianthus ● & ●—1 piece
Stem: Reed diffuser stick—1 piece

WHITE AROMA FLOWER
Lisianthus ○ & ●—1 piece
Stem: Reed diffuser stick—1 piece

ASSEMBLY

1 Make each flower with a little hole at the center.
2 Thread the reed diffuser stick through the flower, use glue to attach it to the flower, and let dry. To use, pour essential oil into a container and insert the diffuser stick.

Hanging Garland

Flower to Flower [see photo page 20]

FLOWERS USED ※ In place of a sepal, use a patching piece the same color as the flower (see Tulip, page 56)

Pom Pom Chrysanthemum
> page 71

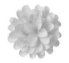

Paper-covered floral wire pieces assembled with floral tape

Pom Pom Mum

MATERIALS (TO CREATE ONE GARLAND)

Pom Pom Mum, Variety 1 ● & ● & ●—9 flowers
Pom Pom Mum, Variety 2 ● & ● & ●—8 flowers
Paper-covered wire, floral tape (white)

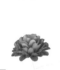
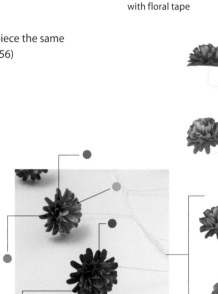

ASSEMBLY

1 Twist each flower's stem around the central floral wire.
2 Wrap floral tape around the joints.

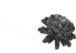

(**TIP**)

Creating the stem

Twist two wires together, one to attach the flower and one as the core. Keep some spare wire at each end. Add new wire as needed to make the piece longer.

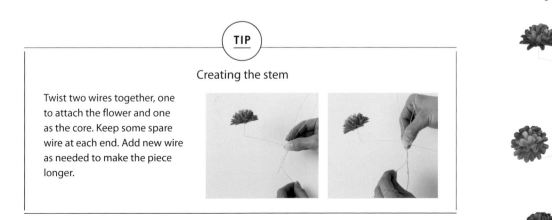

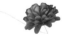

Almost Seventeen [see photo page 22]

FLOWERS USED

Peony
> page 50

Damask Rose
> page 65

Rosebud
> page 66

Small Flower > page 93, Small Flower A template;
page 94, Small Flower B template

MATERIALS (FOR ONE BOUQUET)

Peony & ● & ○ & ●—2 flowers
Damask Rose ● & ● & ○ & ●—2 flowers
Rosebud ● & ○ & ●—2 flowers
Small Flower ○—5 flowers
Leaves: page 95, Leaf A template) ●—5 leaves
Stems: paper-covered wire—16 pieces, floral tape,
 dark green cellophane

ASSEMBLY

1 Make the small flowers.
2 Bundle the stems together with floral tape (page 47).
3 Wrap the bouquet in the cellophane.

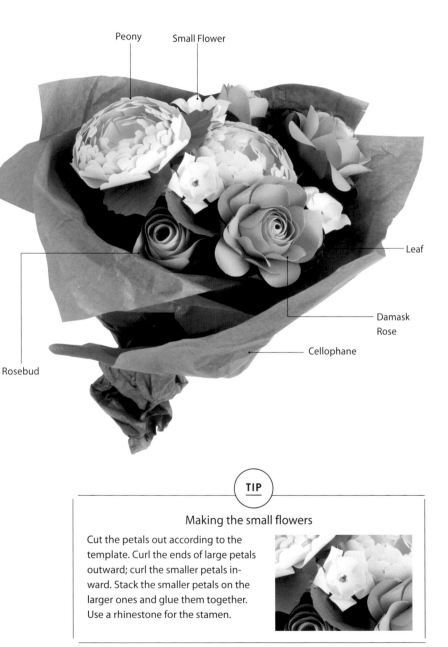

Peony

Small Flower

Leaf

Damask
Rose

Cellophane

Rosebud

TIP

Making the small flowers

Cut the petals out according to the template. Curl the ends of large petals outward; curl the smaller petals inward. Stack the smaller petals on the larger ones and glue them together. Use a rhinestone for the stamen.

Door Ornament
At the Summer Villa [see photo page 23]

FLOWERS USED

Tulip
> **page 55**

Lavender
> **page 61**

Lisianthus
> **page 63**

Semi-Double Mum
> **page 72**

MATERIALS (FOR ONE ORNAMENT)

Tulips ● & ○—2 flowers, ● & ●—3 flowers
Lavender ●—4 clusters, ●—4 clusters
Lisianthus ○ & ●—1 flower
Semi-Double Mum ○ & ○—2 flowers;
 ○ & ○—2 flowers
Leaves: page 95, Leaf F template ○—19 leaves
Stems: paper-covered wire—37 pieces, floral tape,
 metal wire (~ 3 feet / 1 m), ribbon

ASSEMBLY

1 Wrap floral tape around the metal wire. Coil into three loops,
 leaving some excess at one end. Secure with tape.
2 Arrange the flowers around the coil. Wrap each stem around the coil
 and affix with floral tape.
3 Add the leaves at the end of the wire and between flowers, securing
 with floral tape.
4 Tie the ribbon to the top to complete.

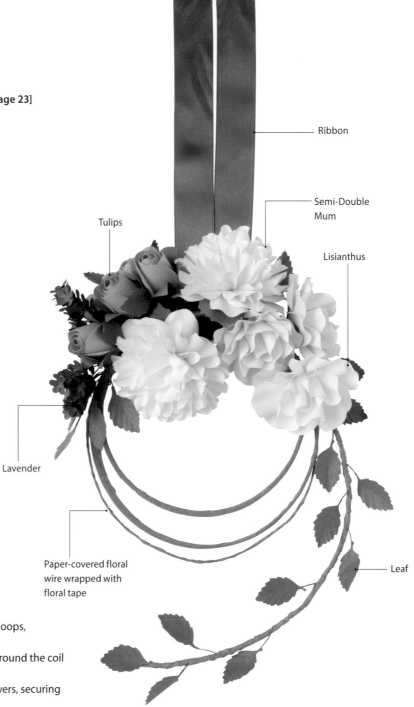

Ribbon

Tulips

Semi-Double Mum

Lisianthus

Lavender

Paper-covered floral wire wrapped with floral tape

Leaf

Ophelia's Song [see photo pages 24–25]

FLOWERS USED ※ Make the poppies and lisianthus with leaves.

Poppy
> page 48

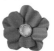

Hydrangea
> page 59

Sunny Smile Sunflower > page 61

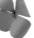

Lavender
> page 61

Lisianthus
> page 63

Poinsettia
> page 73

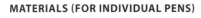

MATERIALS (FOR INDIVIDUAL PENS)

Poppy ● & ● & ●—3 flowers
Leaves: page 95, Leaf F template ●—9 leaves
Stems: paper-covered wire—12 pieces

Hydrangea ○ & ●—1 cluster
Leaves: page 95, Leaf E template ●—2 leaves
Stems: paper-covered wire—13 pieces

Sunny Smile Sunflower ● & ●—1 flower
Leaf: page 95, Leaf E template ●—1 leaf
Stems: paper-covered wire—2 pieces

Lavender ● & ●—1 cluster
Stems: paper-covered wire—10 pieces

Lisianthus ○ & ●—3 flowers
Leaves: page 95, Leaf A template ●—6 leaves
Stems: paper-covered wire—9 pieces

Poinsettia ● & ●—1 flower
Stem: paper-covered wire—1 piece

Floral tape, 1 ballpoint pen for each flower

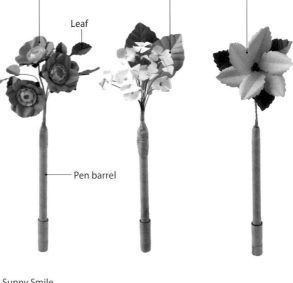

Poppy
Hydrangea
Poinsettia
Leaf
Pen barrel

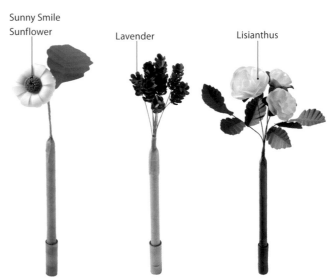

Sunny Smile Sunflower
Lavender
Lisianthus

HOW TO MAKE

Make each flower, and attach the flower to the ballpoint pen with floral tape.

Hanging Ornament

Prayer [see photo page 26]

FLOWERS USED　※ Make all flowers without a sepal or stem.

Easter Lily
> page 58

Damask Rose
> page 65

Small Flowers > Petals: page 92, template 92-7
Stamen: page 95, Stamen D template, rhinestone

MATERIALS (FOR ONE ORNAMENT)

Easter Lily ○—9 flowers
Damask Rose ●—7 flowers
Small Flowers ● & ◐—9 flowers

Styrofoam ball (2⅜-in / 6-cm diameter)—1 piece; **cotton pearls**—
 12 pieces; **drop bead**—1 piece; **eye pins**—14 pieces, **chain**—1 piece;
 double-sided tape

ASSEMBLY

1　Make the small flowers. Stick double-sided tape on the back of each flower.
2　Link the cotton pearls together with eye pins. Connect the drop bead with
 a head pin at the end to complete the dangling charm.
3　Apply glue to the back of each flower and attach them to the Styrofoam ball
 until it is covered.
4　At the top of the whole ornament, add an eye pin to link the chain.

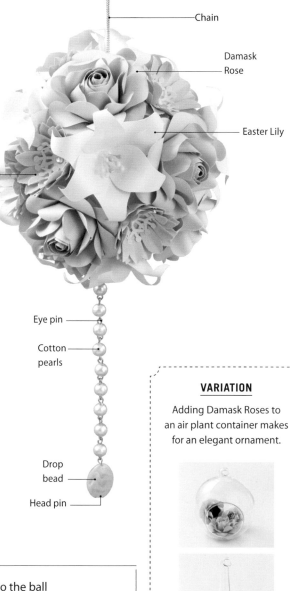

Chain

Damask Rose

Easter Lily

Small flower

Eye pin

Cotton pearls

Drop bead

Head pin

VARIATION

Adding Damask Roses to
an air plant container makes
for an elegant ornament.

(TIPS)

Making a small flower

For one flower: Make four cutouts
of template 92-7 for the petals.
Make two cutouts of Stamen D.
Crease and stack the petals as in
steps 2–3 on page 57. Stack and
attach the stamen and set the
rhinestone in the center.

Gluing the flowers to the ball

Observe the size of the flowers
before making the arrange-
ment. As you fit the flower on
the ball, try to balance not just
the colors, but the height of
the flowers as well.

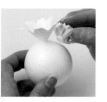

The First Waltz [see photo page 27]

FLOWERS USED ※ Make the main flowers without a sepal or stem. For Small Flower 2, make the sepal the same color as the petals.

Carnation
> page 53

Pom Pom Mum
> page 71

Hybrid Tea Rose
> page 70

Small Flower 1 > page 92, template 92-13; page 94, Sepal H template; pearl beads for the stamen
Small Flower 2 > page 92, Small Flower C template; page 92, template 92-13

MATERIALS (FOR ONE CORSAGE)

CARNATION GLASS CORSAGE
Carnation ●—1 flower
Leaves: page 95, Leaf F template
 ●—2 leaves
Leaves: page 95, Leaf A template
 ●—2 leaves
Small Flower 1 ●—3 flowers
Small Flower 2 ●—3 flowers

HYBRID TEA ROSE GLASS CORSAGE
Hybrid Tea Rose ●—1 flower
Leaves page 95, Leaf F template ●—2 leaves
Leaves page 95, Leaf A template ●—2 leaves
Small Flower 1 ●—3 flowers
Small Flower 2 ●—3 flowers

POM POM MUM GLASS CORSAGE
Pom Pom Mum ●—1 flower
Leaves page 95, Leaf F template ●—2 leaves
Leaves page 95, Leaf A template ●—2 leaves
Small Flower 1 ●—3 flowers
Small Flower 2 ●—3 flowers

For each corsage:
Wire hoop—1 piece; metal jump rings—7 pieces; eye pins—3 pieces; large tag pendant charm—1 piece; small tag pendant charms—3 pieces

ASSEMBLY

1 Make Small Flowers 1 and 2.
2 Coat all pieces with decoupage glue for waterproofing and added strength.
3 Attach the leaves to the large pedestal link; glue the main flower to the leaves.
4 Attach each Small Flower 1 to a small pedestal link.
5 Thread an eye pin through a paper patch, loop the straight end, and cut. Add glue to secure the paper to the loop.
6 Glue Small Flower 2 to the patch. Repeat with all flowers.
7 Thread all pieces onto a wire hoop.

Carnation Glass Corsage

Small Flower 2
Eye pin
Small Flower 1
Small tag charm
Leaves
Jump ring
Large tag charm
Wire hoop
Carnation

Hybrid Tea Rose Glass Corsage

Pom Pom Mum Glass Corsage

Hybrid Tea Rose

Pom Pom Mum

TIP

Making Small Flowers 1 and 2

Use template 92-13 to make the Small Flower 1 petals. Curl petals outward. Stack and glue the smaller petals on top of the larger ones. Use pearl beads as the stamen. Use Small Flower C and 92-13 templates for Small Flower 2. Curl petals inward and glue, then stack and glue the smaller petals on top of the larger ones. A tag pendant charms (shown below) is used to attach the flowers to the wire hoop.

What's Your Wish?

[see photo page 28]

MATERIALS (FOR ONE CORSAGE)

Anemone ● & ● & ●—1 flower, ● & ● & ●—1 piece
Small Flower 1 ● & ● & ●—3 flowers
Small Flower 2 ● & ●—3 flowers
Small Flower 3 ● & ●—3 flowers
Leaves page 95, Leaf F template) ●—15 leaves
Stem: paper-covered wire—26 pieces, floral tape
Ribbon, brooch pin—1 piece each

Brooches

Is This Love? [see photo page 29]

FLOWERS USED

Dandelion > page 51

※For Brooch 1, use a paper patch in place of the sepal. Brooch 2 has no sepal or leaf. Brooch 3 has leaves, but no sepal.

MATERIAL (FOR EACH KIND)

BROOCH 1 Dandelion ◯ —3 flowers
Safety pin—1 piece; **jump ring**—3 pieces; **eye pin**—3 pieces

BROOCH 2 Dandelion ◯ —2 flowers, ◯—1 flower
Brooch pin with base—1 piece
Leaf-shaped jewelry component—1 piece

BROOCH 3 Dandelion —1 flower
Leaf: page 95, Leaf A template, cut in half ● —2 leaves
Brooch pin with base—1 piece

ASSEMBLY

BROOCH 1

1 Brush decoupage glue onto the flowers and let dry (page 47).
2 Thread a paper patch onto an eye pin and secure with glue. Repeat for each flower.
3 Glue the flowers to the patches, then connect the eye pins to the safety pin.

BROOCH 2

1 Brush decoupage glue onto the flowers and let dry (page 47).
2 Attach the leaf component to the broach pin with glue. Allow to set.
3 Glue the flowers to the leaf component.

BROOCH 3

1 Brush decoupage glue onto the flowers and let dry (page 47).
2 Glue the leaves to the base of the pin.
3 Glue the flowers to the leaves.

Brooch 1

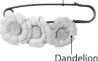

Safety pin

Dandelion

Brooch 2

Brooch pin with a base

Dandelion

Leaf component

Brooch 3

Brooch pin with a base

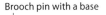
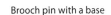

Dandelion

Leaf

FLOWERS USED

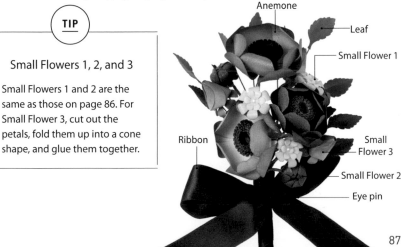

Anemone > page 52

Small Flower 1 > page 92, template 92-13 (petals); page 94, Sepal H template; pearl beads for the stamen
Small Flower 2 > page 92, template 92-9 (petals); page 92, template 92-13 (sepal)
Small Flower 3 > page 94, Small Flower B template; page 94, Sepal H template

ASSEMBLY

1 Use a stamp pad to tint the petals (see page 47).
2 Brush the leaves and flower parts with decoupage glue and let dry.
3 Bundle them together with floral tape (page 47).
4 Tie a ribbon to the bundle and hold the ribbon in place with glue.
5 Attach the brooch pin to the back of the ribbon. Use the paper-covered wires to further secure it.
6 Tie a bow with the ribbon to hide the pin.

TIP

Small Flowers 1, 2, and 3

Small Flowers 1 and 2 are the same as those on page 86. For Small Flower 3, cut out the petals, fold them up into a cone shape, and glue them together.

Anemone

Leaf

Small Flower 1

Small Flower 3

Ribbon

Small Flower 2

Eye pin

Photo Frame

The Secret Letter [see photo page 30]

FLOWERS USED ※ Make the flowers without a sepal or stem.

Damask Rose
> page 65

Rosebud
> page 66

Climbing Rose
> page 68

Pom Pom Mum
> page 71

Small Flowers 1 and 2 > page 92, template 92-13; page 94, Sepal H template; pearl beads for the stamen

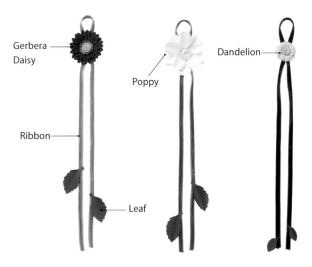

Pom Pom Mum

Climbing Rose

Rosebud

Leaf

Small Flower 2

Damask Rose

Small Flower 1

MATERIALS (FOR ONE FRAME)

Damask Rose ○—2 flowers
Rosebud ●—4 flowers
Climbing Rose ●—2 flowers
Pom Pom Mum ○ & ○—3 flowers
Small Flower 1 ●—6 flowers, ●—6 flowers
Small Flower 2 ●—7 flowers, ●—6 flowers
Leaves: page 95, Leaf F template ●—5 leaves, ●—5 leaves

Photo frame —1 piece

ASSEMBLY

1 Make Small Flowers 1 and 2.
2 Glue the roses and mums to opposite corners of photo frame.
3 Add the Small Flowers to the remaining areas as shown.

TIP

Making the small flowers

Cut out all parts. For Small Flower 1, crease the petals lengthwise. Stack and glue the smaller petals on top of the larger ones. Use pearl beads for the stamen. For Small Flower 2, curl the petals inward and stack and glue the petals the same way.

Bookmarks

A Date at the Library [see photo page 31]

FLOWERS USED ※ Make the flowers without a sepal or stem.

Poppy
> page 48

Dandelions
> page 51

Gerbera Daisy
> page 57

MATERIALS FOR EACH BOOKMARK

POPPY BOOKMARK
Poppy ○—2 flowers
Leaves page 95, Leaf A template ●—2 leaves

DANDELION BOOKMARK
Dandelion ●—1 flower
Leaves page 95, Leaf F template ●—2 leaves

GERBERA DAISY BOOKMARK
Gerbera ● & ● & ○—1 flower
Leaves page 95, Leaf A template ●—2 leaves

Ribbon (your choice of color)

Gerbera Daisy

Poppy

Dandelion

Ribbon

Leaf

ASSEMBLY

1 Fold the ribbon in half; cross the strands to make a loop.
2 Glue the flower to where the strands cross.
3 Glue the leaves to the ends of the ribbon.

Tassels

The Nightingale [see photo page 32]

FLOWERS USED ※ For the Tulip and Gerbera Daisy, use a paper patch that matches the color of the flower for the sepal.

Lily of the Valley
> page 49

Gerbera Daisy
> page 57

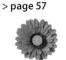

Tulip
> page 55

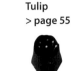

Small Flower 1 > Page 92, template 92-13; page 94, Sepal H template
Small Flower 2 > Page 94, Sepal H template; use pearl beads for the stamen

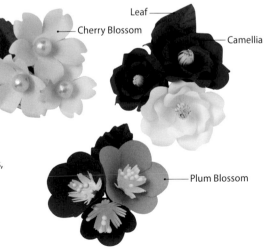

Small Flower 1
Leaf
Lily of the Valley
Gerbera Daisy
Tassel
Tulip
Small Flower 2

MATERIALS FOR EACH TASSEL

GERBERA DAISY & LILY OF THE VALLEY TASSEL
Lily of Valley ◯ & ● & ●—1 cluster
Gerbera Daisy ◐ & ● & ◐—1 flower
Small Flower 1 ◯ & ◐—3 flowers
Leaves: page 95, Leaf F ●—2 leaves
Stems: paper-covered wire—7 pieces, floral tape
Tassel—1 piece each

TULIP TASSEL
Tulip ●—2 flowers
Small Flower 2 ●—3 flowers
Leaves: page 95, Leaf F template ●—2 leaves
Stems: paper-covered wire—7 pieces, floral tape
Tassel—1 piece

ASSEMBLY

1 Refer to page 88 for Small Flower 1 directions. Cut out the parts for Small Flower 2. Curl the tips of the petals inward. Glue pearl beads to the center for the stamen.
2 Bundle the flowers and leaves together with floral tape.
3 Attach the bundle to the top part of the tassel.

Magnets

Once Upon a Sunny Day [see photo page 33]

FLOWERS USED ※ Make the flowers without a sepal or stem.

Camellia
> page 73

Plum Blossom
> page 74

Cherry Blossom
> page 75

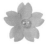

MATERIALS (FOR EACH MAGNET)

CAMELLIA MAGNET
Camellia ● & ◐—2 flowers, ◯ & ◐—1 flower
Leaf: page 95, Leaf H template—1 leaf

PLUM BLOSSOM MAGNET
Plum Blossom ● & ◯—1 flower, ●—2 flowers, ● & ◯—1 flower
Leaf: page 95, Leaf A template ●—1 leaf

CHERRY BLOSSOM
Cherry Blossom ◯—2 flowers, ◯—1 flower
Leaf: page 95, Leaf F template ●—1 leaf

Magnet—1 per flower

Leaf
Cherry Blossom
Camellia
Plum Blossom

ASSEMBLY

1 Glue the leaves to the magnet and let dry.
2 Glue the flowers to the leaf.

Coronet

Daydreaming

[see photo page 34]

FLOWERS USED ※ For all flowers, use a paper patch of matching color for the sepal.

English Daisy > page 54

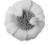

Gerbera Daisy > page 57

MATERIALS (FOR ONE CORONET)

English Daisy ◯ & ⬤ —14 flowers
Gerbera Daisy ⬤ & ⬤ & ◯—9 flowers
Leaves: page 95, Leaf F template ⬤ —10 leaves; ⬤ —18 leaves
Floral tape, paper-covered wire

ASSEMBLY

1 Measure the metal wire to fit around the wearer's head. Tie together three loops of that size with floral tape.
2 Wrap the stems of the flowers and leaves around the wire circlet.
3 Use floral tape to secure the flowers and leaves in place.

Bracelet

He Loves Me, He Loves Me Not

[see photo page 35]

FLOWERS USED ※ Make the flowers without stems.

English Daisy > page 54

Gerbera Daisy > page 57

MATERIALS (FOR ONE BRACELET)

English Daisy ◯ & ⬤ —6 flowers
Gerbera Daisy ⬤ & ⬤ & ◯—3 flowers
Leaves: page 95, Leaf F template ⬤ —6 leaves
Thick paper 2⅜ x 3⅛ in (6 x 8 cm)—1 piece; **fabric** 2⅜ x 3⅛ in (6 x 8 cm) —1 piece; **lobster-claw bracelet clasp and matching chain with crimp connectors**—1 piece; **ribbon** 4¾ x 1½ in (12 x 4 cm)—1 piece

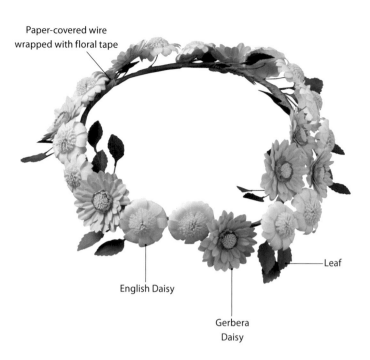

Paper-covered wire wrapped with floral tape

Leaf

English Daisy

Gerbera Daisy

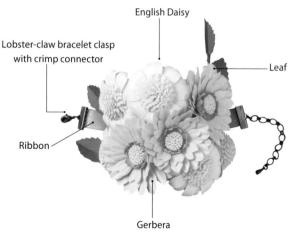

English Daisy

Lobster-claw bracelet clasp with crimp connector

Leaf

Ribbon

Gerbera

ASSEMBLY

1 Apply glue to the thick paper. Glue one side to the center of the length of ribbon; glue the fabric to the other side. Shape the paper to the curve of your wrist, and let the glue dry in that shape.
2 Glue the leaves and flowers onto the fabric. Let the glue dry.
3 Cut the ribbon to the desired size. Use pliers to attach the crimp ends of the clasp and chain to the ends of the ribbon.

Templates

- All template are made to size. Template numbers given in the how-to pages refer to the numbers of the tem plates here.
- Templates can be photocopied for easier use.
- Cut out the photocopied shape and trace the outline on the back of the origami paper with a pencil.

91-3

91-5

91-4

91-1

91-2

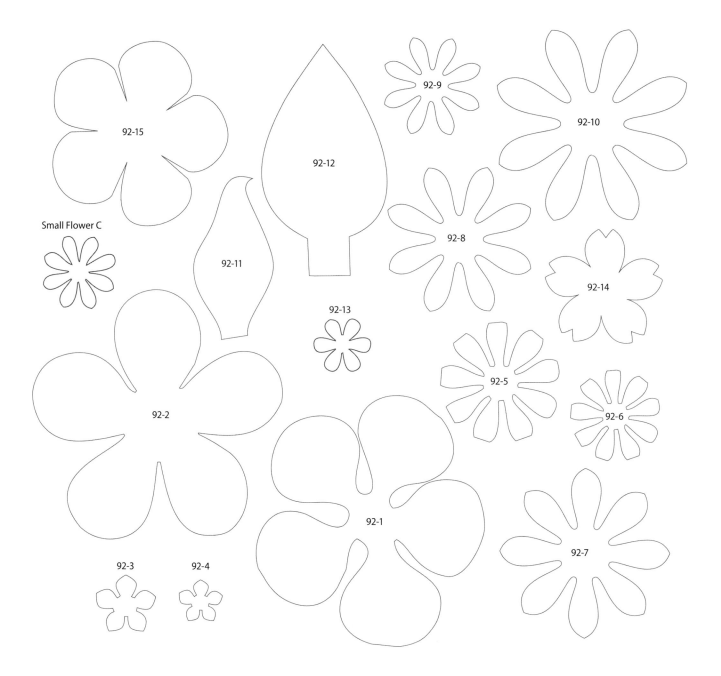

92-15

Small Flower C

92-12

92-9

92-10

92-11

92-8

92-14

92-13

92-2

92-5

92-6

92-1

92-3

92-4

92-7

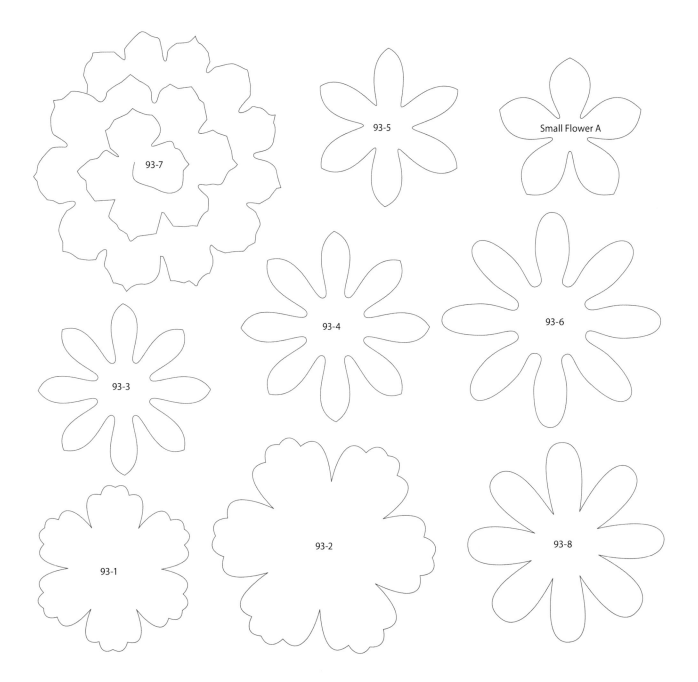

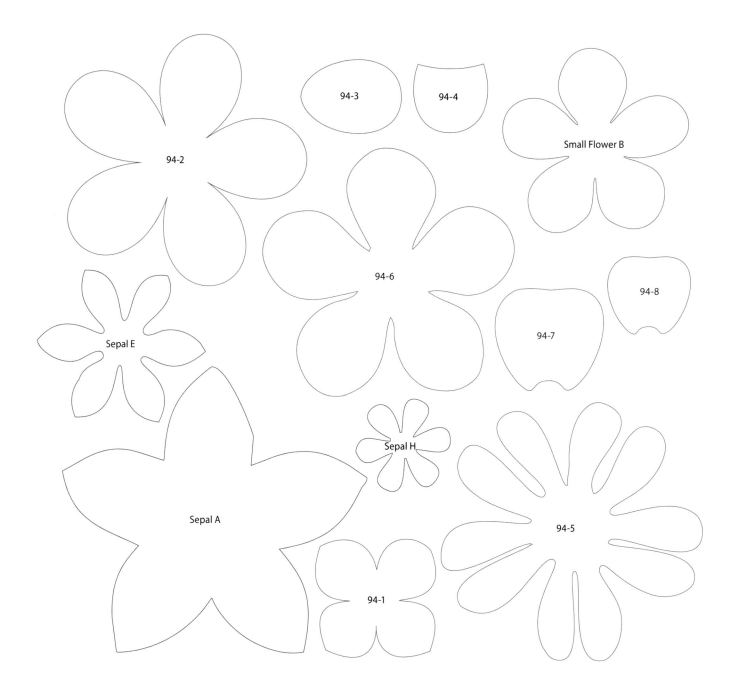

94-2

94-3

94-4

Small Flower B

94-6

Sepal E

94-7

94-8

Sepal A

Sepal H

94-5

94-1

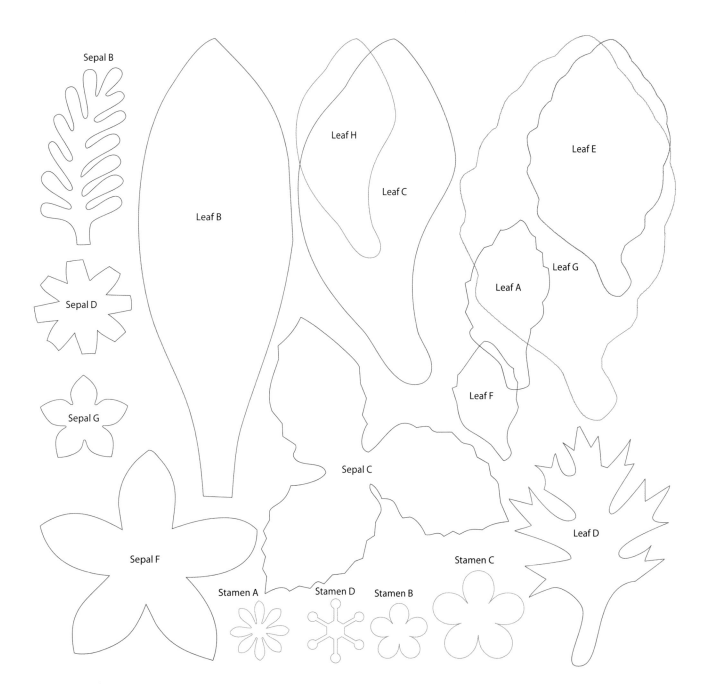

Sepal B

Sepal D

Sepal G

Sepal F

Leaf B

Leaf H

Leaf C

Leaf E

Leaf A

Leaf G

Leaf F

Sepal C

Leaf D

Stamen A

Stamen D

Stamen B

Stamen C

Published by Tuttle Publishing, an imprint of Periplus Editions (HK) Ltd.

www.tuttlepublishing.com

Library of Congress Cataloging-in-Publication data in process

ISBN 978 4 8053 1498 2

Kami de Tsukuru, Honmono Mitaina Hana to Komono
Copyright © Hiromi Yamazaki 2017
English translation rights arranged with NIHONBUNGEISHA Co., Ltd.
through Japan UNI Agency, Inc., Tokyo

English translation copyright © 2019 by Periplus Editions (HK) Ltd.
Translated from Japanese by HL Language Services

STAFF
Photography Yumiko Yokota (STUDIO BAN BAN)
 Norihito Amano (NIHONBUNGEISHA)
Styling Mariko Danno
Design Maya Miyamoto
Editor Fumika Miyoshi (ROBITASHA)

Distributed by
North America, Latin America & Europe
Tuttle Publishing
364 Innovation Drive
North Clarendon, VT 05759-9436 U.S.A.
Tel: (802) 773-8930; Fax: (802) 773-6993
info@tuttlepublishing.com; www.tuttlepublishing.com

Japan
Tuttle Publishing
Yaekari Building 3rd Floor
5-4-12 Osaki, Shinagawa-ku, Tokyo 141 0032
Tel: (81) 3 5437-0171, Fax: (81) 3 5437-0755
sales@tuttle.co.jp; www.tuttle.co.jp

Asia Pacific
Berkeley Books Pte. Ltd.
3 Kallang Sector, #04-01/02, Singapore 349278
Tel: (65) 6280-1330; Fax: (65) 6280-6290
inquiries@periplus.com.sg; www.periplus.com

Printed in China 1811RR
22 21 20 19 18 10 9 8 7 6 5 4 3 2 1

TUTTLE PUBLISHING® is a registered trademark of Tuttle Publishing,
a division of Periplus Editions (HK) Ltd.

About Tuttle "Books to Span the East and West"

Our core mission at Tuttle Publishing is to create books which bring people together one page at a time. Tuttle was founded in 1832 in the small New England town of Rutland, Vermont (USA). Our fundamental values remain as strong today as they were then—to publish best-in-class books informing the English-speaking world about the countries and peoples of Asia. The world has become a smaller place today and Asia's economic, cultural and political influence has expanded, yet the need for meaningful dialogue and information about this diverse region has never been greater. Since 1948, Tuttle has been a leader in publishing books on the cultures, arts, cuisines, languages and literatures of Asia. Our authors and photographers have won numerous awards and Tuttle has published thousands of books on subjects ranging from martial arts to paper crafts. We welcome you to explore the wealth of information available on Asia at **www.tuttlepublishing.com.**